IMAGES
*of America*

# BAINBRIDGE ISLAND

IMAGES
*of America*

# BAINBRIDGE ISLAND

Donald R. Tjossem and
the Bainbridge Island Historical Museum

ARCADIA
PUBLISHING

Copyright © 2013 by Donald R. Tjossem and the Bainbridge Island Historical Museum
ISBN 978-0-7385-9992-2

Published by Arcadia Publishing
Charleston, South Carolina

Printed in the United States of America

Library of Congress Control Number: 2012954719

For all general information, please contact Arcadia Publishing:
Telephone 843-853-2070
Fax 843-853-0044
E-mail sales@arcadiapublishing.com
For customer service and orders:
Toll-Free 1-888-313-2665

Visit us on the Internet at www.arcadiapublishing.com

*This book is dedicated to those who have ever lived on
Bainbridge Island or presently live on the island and to
those who are interested in its rich diversified history.*

# CONTENTS

# ACKNOWLEDGMENTS

I would like to thank the staff and volunteers of the Bainbridge Island Historical Museum; without their support and encouragement this publication would not have been possible. The staff members include the following: Henry R. "Hank" Helm, executive director; Rick Chandler, curator/facilities coordinator; Katy Curtis, outreach coordinator; and Dan Groff, administrative coordinator. These staff and all volunteers at the museum are seriously dedicated to preserving the history of Bainbridge Island for all to enjoy, including future generations to come.

All images appearing in this book were provided by the Bainbridge Island Historical Museum. Their image library was so complete, with over 6,000 images, there was no need to explore alternate sources for this book.

From the book's conception, my wife, Becky Alexander, has been a major influence and has been "on call," at all times, when it was necessary to share an idea or receive input on what was going into this book. She has been supportive, and I would like to thank her for her efforts. I also would like to thank editor Alyssa Jones and senior production editor Michael Litchfield at Arcadia Publishing for all of their assistance and guidance in completing this project. They have both been very supportive and helpful in making this project a reality. Volunteer reviewers Thomas Thatcher, Karen Beierle, Joan Piper, David Thorne, and John Newland-Thompson were also of great assistance.

All of the amateur and professional photographers who have recorded these glimpses of history for future generations need to be recognized, as without them, this book and many of the historical events that preceded us could not be remembered so vividly. They are truly the ones "behind the scenes" and most often deserve more credit than they are given as real historians.

# INTRODUCTION

The history of inhabited Bainbridge Island predates written documents but was certainly over 5,000 years ago, as hundreds of archeological remains along the shoreline would indicate. One of these findings is a petroglyph at Agate Point that may have been created two or three thousand years ago. The most recent Native American people were known as the sakh-TAHBSH people, better known as the Suquamish tribe.

Chief Kitsap greeted Capt. George Vancouver, the first English explorer to view Bainbridge Island, in 1792. Vancouver did not recognize it as an island because he did not find Agate Passage. The explorers communicated with the Native Americans with sign language, as there was not a common language at that time. It was not until over 50 years later, in 1841, that the US Exploring Expedition headed by Capt. Charles Wilkes came and discovered the island was not connected to the mainland. Wilkes named it Bainbridge Island in honor of Commodore William Bainbridge, a naval hero of the War of 1812 and commander of the frigate USS *Constitution*.

George Anson Meigs came to Puget Sound in 1854 and started a lumber mill at Port Madison on Bainbridge Island. It would eventually be the major industry in the area. Port Madison became the county seat of Slaughter County, now Kitsap County, from 1857 until 1893. Shortly after the mill closed, Port Orchard became the Kitsap County seat.

In 1864, William Renton started the Port Blakely Mill, which delivered lumber to ports all over the world. This mill burned down and was rebuilt in 1888. It was up and running just five months later. In terms of board feet produced, it was reputed to be the largest of its kind in the world.

In 1899, the US Army established Fort Ward, which housed massive 16-ton guns overlooking Rich Passage. Fort Ward remained either an Army or Navy base until 1960.

The Hall Brothers Shipyard was moved from Port Blakely to Eagle Harbor in 1902, bringing employment and supporting businesses to the area. The residents of the community Madrone changed the name to Winslow to honor Winslow Hall, a son of Henry Knox Hall, who was the Hall patriarch at the time when the yard was moved.

Yama, a Japanese community, was established near the Port Blakely Mill about 1890 for mill workers. This community grew to about 300 residents by the time the mill closed. There is very little remaining evidence of it today.

When World War II broke out, Japanese Americans from Bainbridge Island became the first individuals moved to relocation centers. They were sent first to Mazanar, California, and later on to Minidoka, Idaho. Following the war, many of these Japanese Americans returned to the island as well as many of those who had served honorably in the war.

Agate Passage Bridge from the western mainland opened in 1950 and changed the island forever. Now, the island had a land connection for vehicles that could be used at any time. Cross-sound bridges to connect to Seattle are occasionally debated to this day.

On February 28, 1991, the City of Winslow annexed the rest of the island, and the entire island became the City of Bainbridge Island. It presently has a population of approximately 23,000 people.

As we move on into the future, we hope this book will give the reader a glimpse of Bainbridge Island's past. This book is not an attempt to be a comprehensive study of Bainbridge Island's history but merely a photographic rendition of what a person may have seen at different times during its earlier years.

# One

# PIONEERS

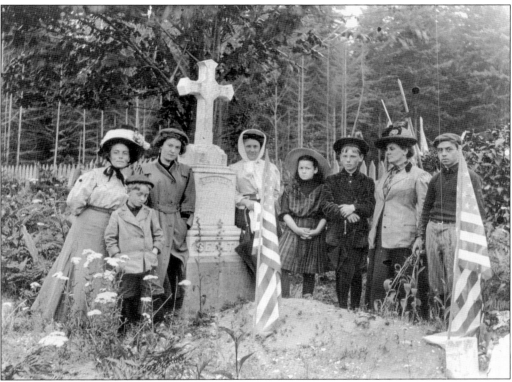

These people are paying respects to Chief Seattle, more accurately called Chief Sealth, at his gravesite, which is located just over the Agate Passage Bridge from Bainbridge Island on the Suquamish reservation. Chief Seattle has been said to be the greatest personality of all the Puget Sound Indians. Although the main tribal and potlatch houses of the Suquamish were on the mainland opposite the north end of Bainbridge Island, there were many villages and camps on the shores, which were their camps used for berry picking, fishing, and root digging. By all accounts, Chief Seattle and the people in his tribe were very peaceful and cooperative with new settlers to Bainbridge Island and the surrounding area. Many of his tribe worked in the mills and on the farms of the early pioneers that were coming to the area. Seattle was named after Chief Sealth at the suggestion of Dr. David S. Maynard, who was an early settler in the Seattle area. Chief Sealth was born in about 1786 and passed away on June 7, 1866. This gravestone still stands at the south edge of the town of Suquamish.

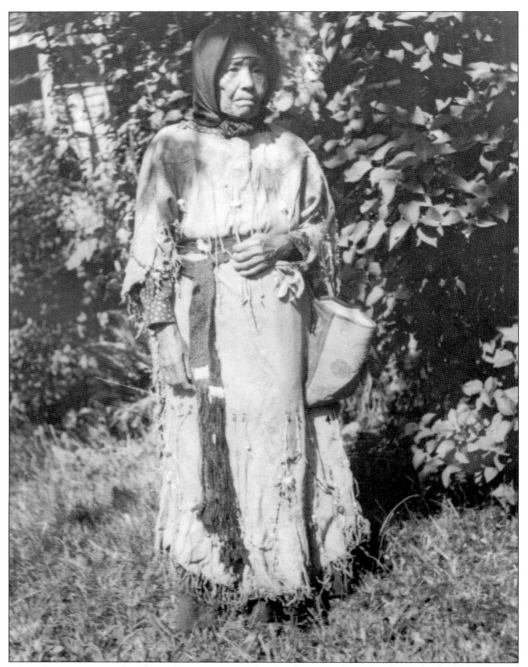

Mary Sam is reported to have been captured by the Suquamish in battle with the Yakima and Klickitat tribes. She lived on Bainbridge Island until her death on December 29, 1923, and is buried on the Port Madison Reservation at Suquamish. She indicated she was an Indian princess and often wore her mother's clothes and the nine-foot-long ceremonial belt that was made of her deceased aunt's hair. She worked as a domestic for many island families for many years.

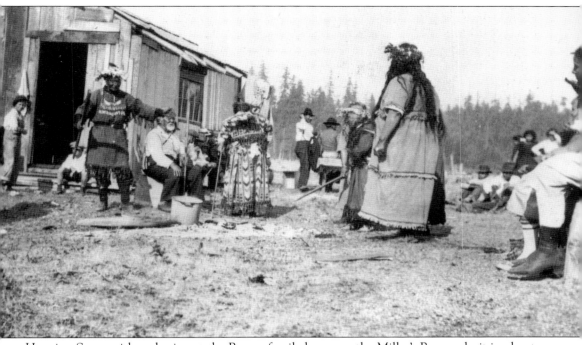

Here is a Suquamish gathering at the Rogers family home on the Miller's Bay sandspit in about 1920. William Rogers is seated to the middle left in the white shirt.

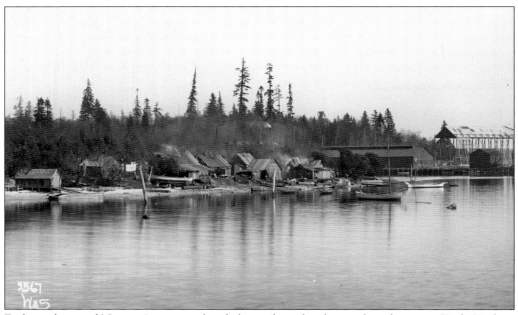

Early workers and Native Americans lived alongside each other in these homes at Eagle Harbor; part of the Hall Brothers shipbuilding facility is seen to the right in the photograph above. This part of Eagle Harbor is now a public park with very few signs of the shipbuilding or residences remaining. Below is a closer look of the same beach, at a different angle, on Eagle Harbor. Note the tall mast to the far right.

Port Blakely Native American "Big Tom" was a great-uncle of Charlie Sigo, the curator of the Suquamish Museum in 1989. The Suquamish Museum and Cultural Center has just been renovated and is a wonderful source for in-depth historical information on the Suquamish tribe. It is located just across Agate Passage from Bainbridge Island on the Port Madison Indian Reservation.

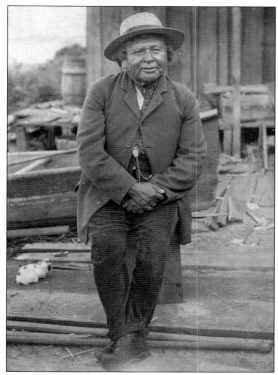

These are sailing ships anchored in Eagle Harbor in 1908. In the foreground is the *Benjamin F. Packard*, whose captain was William F. Curtis, brother-in-law of Winslow pioneer John R. Parfitt.

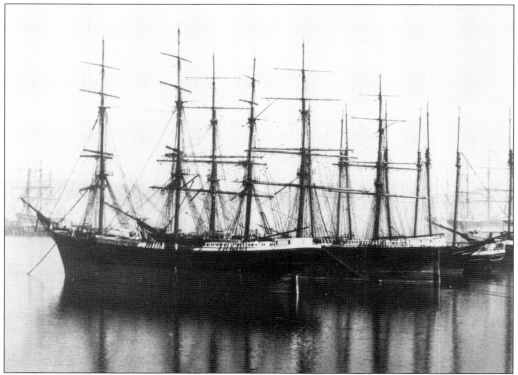

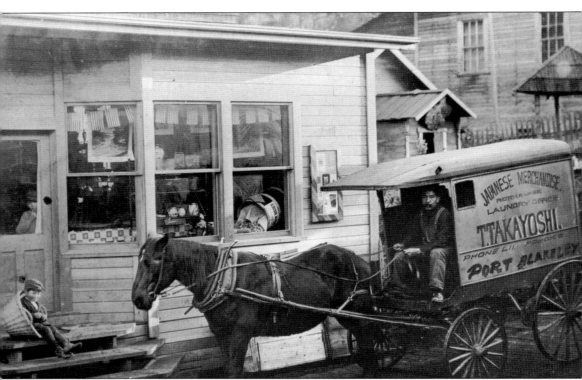

In the early 1900s, the Tamegoro Takayoshi family operated a grocery store and ice cream parlor in Yama, a Japanese settlement near Port Blakely. The Takayoshi families were very enterprising, as this store had Yama's first telephone, a photography studio, and a watch repair shop. They were also agents for a Seattle laundry company. Tamegoro was sometimes addressed as "General," although that was not his rank in the Japanese army. He was considered the unofficial mayor of Yama.

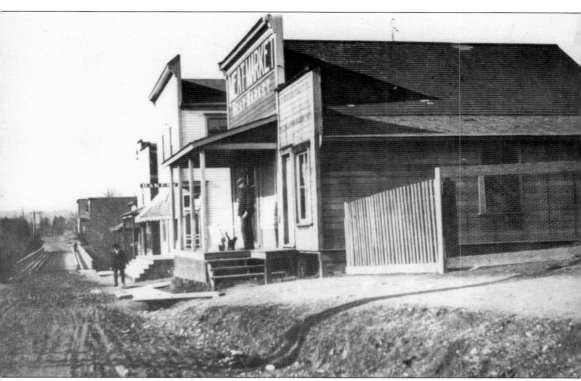

Downtown Winslow is shown in this early-1900s photograph, taken from the east side looking west on Winslow Way. Included is the meat market owned by the Nakata family, in addition to other enterprises on Bainbridge Island at that time, including a berry farm, laundry, and grocery.

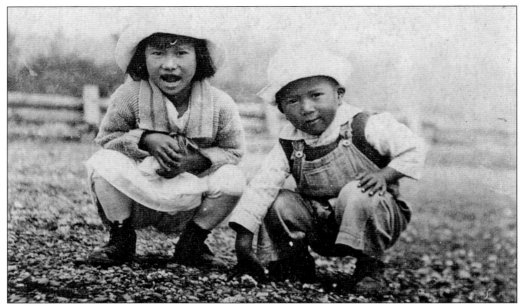

Chiyeko "Chick" Oyama (Watanabe) and Noboru Oyama are posing for this 1924 photograph on Bainbridge Island, where their parents live. Both were to be relocated to Manzanar shortly after World War II broke out, as many other Japanese American citizens were at that time. Their parents, Kametaro Oyama and Kamiyo Yamada, both resided in Eagle Harbor at that time, according to census information.

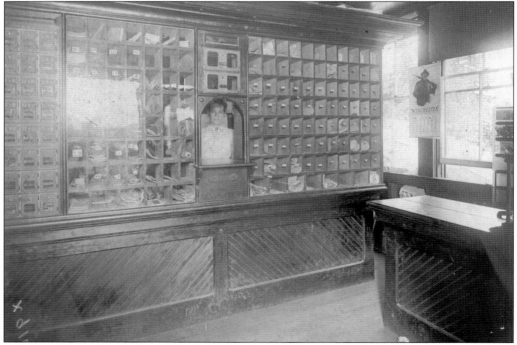

Sadie Woodman, shown here, was the postmistress of the third Winslow Post Office. The calendar on the wall shows that this photograph was taken in 1913.

Martin Jerome Lincoln is pleased with this wild bird he shot in about 1900. At this time, most meat and other staples did not come from the local grocery store.

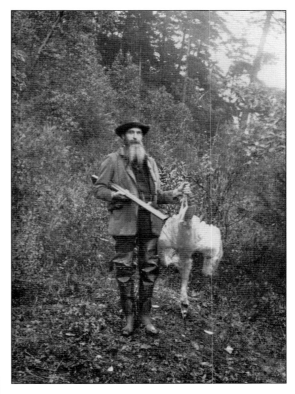

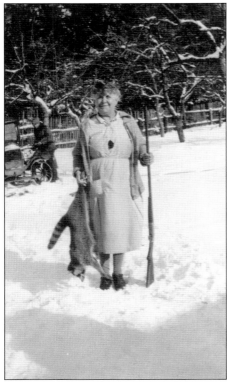

Jennie Lincoln is quite proud of the raccoon she shot in this photograph. At this time, in the early 1900s, raccoons were plentiful and considered edible.

George Southwell Brett was a pastor of the Eagle Harbor Congregational Church and was publisher of the *Eagle Harbor Pilot*, a monthly newspaper, prior to 1912. Later, he became the associate editor of the *Bainbridge Island Gazette*, the first weekly newspaper on Bainbridge Island.

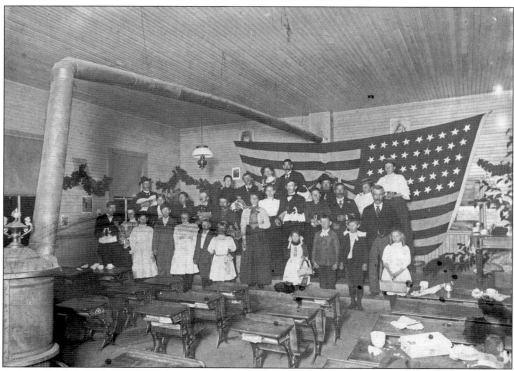

A Seabold School basket social was held in 1899. Note the 45-star flag in the background.

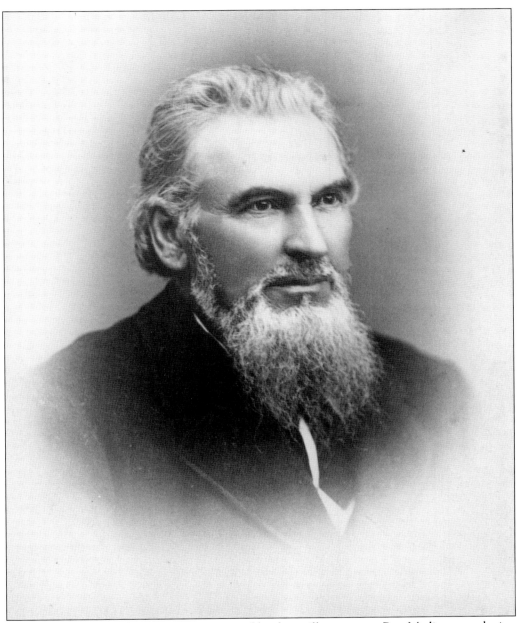

George A. Meigs was the pioneer international lumber mill operator at Port Madison, employing many of the Suquamish tribe, from 1854 to 1872. He was on the Board of Regents for the University of Washington during the early 1860s. In 1892, the Dexter Horton Bank took title to the mill property, being the mill's largest creditor. On March 3, 1887, Meigs accidentally fell from a pier while on a trip to Seattle and died.

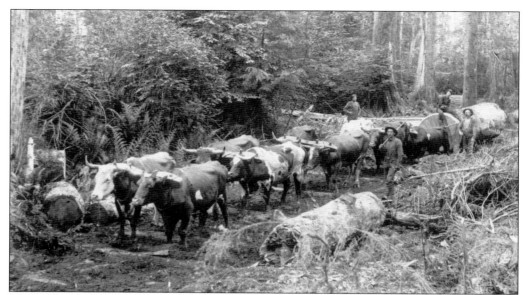

The lumber mill at Port Madison had a ready source of lumber to cut, as shown by these oxen skidding logs down a skid road. Logs were dragged to either the mill, or to water where they could be towed in a log boom to the mill.

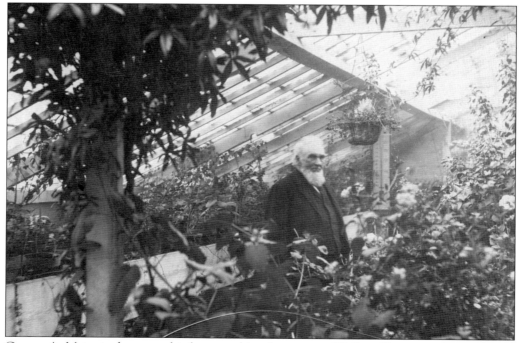

George A. Meigs is shown on his large working farm west of Rolling Bay, raising animals and vegetables that were grown for workers in his mill. Washington was a territory for the entire time he resided at Port Madison, and his daughter Lillian was the first white child recorded to have been born on Bainbridge Island.

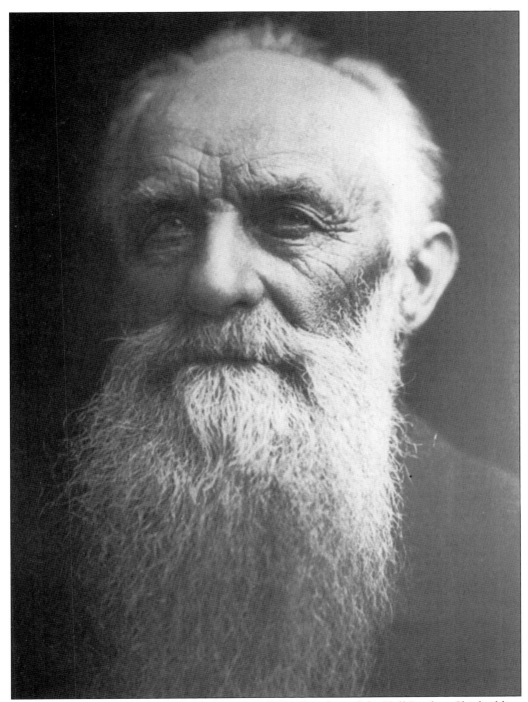

Henry Knox Hall, along with his brothers Isaac and Winslow, formed the Hall Brothers Shipbuilding Company, one of the most famous in the world. Henry managed the construction while his brothers took care of the design and customers. Their tall ships were counted among the most beautifully designed and built commercial sailing ships in the Pacific.

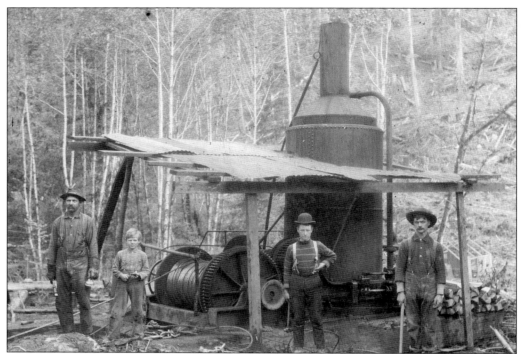

Logging in 1885 normally involved a steam donkey. These loggers are reportedly logging in the Manzanita area. Note the young boy apparently learning the logging trade at an early age. Donkey engines were sometimes called steam donkeys; they were the steam engines that operated winches used in logging operations.

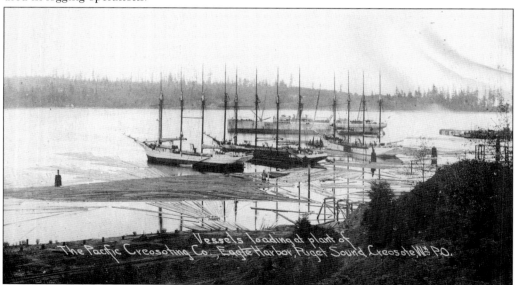

Vessels are shown loading treated logs at the Pacific Creosoting Company in Eagle Harbor. This company coated logs for export with creosote at this site. The company even had its own post office at one time. Eagle Harbor was designated a Superfund site in 1987 due to pollution this facility was causing. Most all of the facilities are gone now, and a park is being developed.

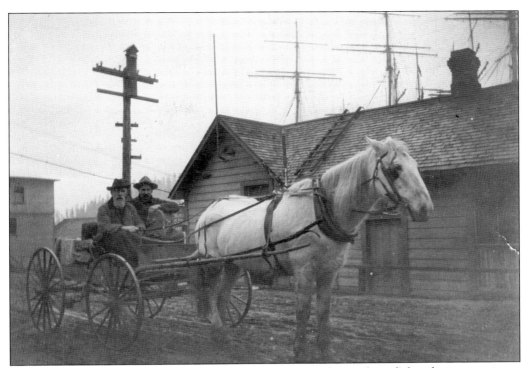

Capt. Charles J. Syversen, on the left with a friend, was one of Puget Sound's best-known mariners. He ran away to go to sea at age 12, starting as a cabin boy, and arrived at Port Blakely in 1883 at the age of 39. He was a very early director of the Crystal Springs School.

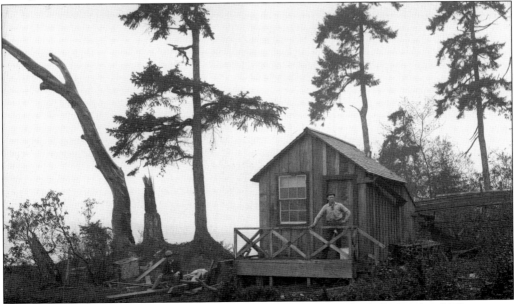

Shown here is a photograph of what was commonly called a "bachelor's cabin." These were structures many of the single mill workers or loggers lived in, since they could be built quite quickly and easily with the materials at hand.

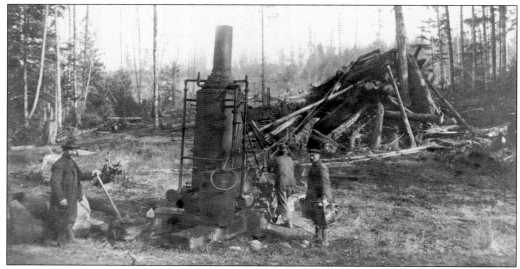

This donkey engine is shown along with a stump pile with early settlers clearing the land. Ole Monsaas is at the controls, Carl Pedersen is the water boy, and Martin Torvanger is chopping wood.

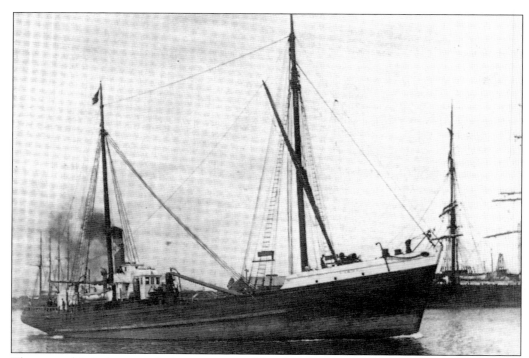

The steamship *Lakme* was the last commercial freighter built at the Meigs Mill and Shipbuilding Company, located at Port Blakely. *Lakme* had a gross tonnage of 529 tons and a 366-horsepower compound engine. It was scrapped in 1927.

Harry Wallace was the first dockmaster for the Hall Brothers Shipyard and did the maintenance and necessary diving for the tracks and rollers that were required to launch the ships. Due to the health hazards of the industry, he went into the retail grocery, hardware, and feed business after 1914.

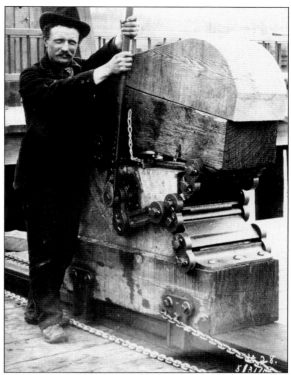

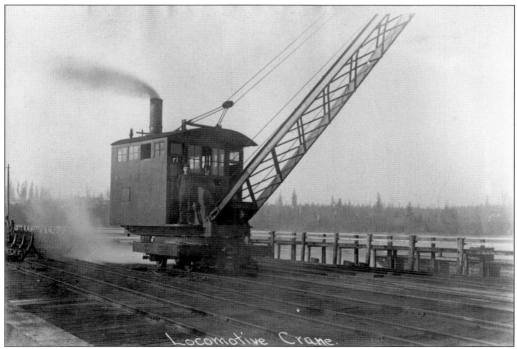

This locomotive crane was used at Port Blakely in the early days of millwork and shipbuilding. It was used to move equipment to and from the shipbuilding site and the mill along the waterfront.

Wearing a dress, Dorothy Cave is shown in this early picture with a team of horses. She was a longtime grade school teacher who celebrated her 60th wedding anniversary to Wilbur Nystrom on August 23, 1987.

Dr. Cecil Corydon Kellam first came to practice medicine at the Port Blakely Mill about 1889, when he was hired by Capt. William Renton to take care of any injuries to the mill workers. Originally, his rounds were made in a horse and buggy. Serving both the general island population and the military at Fort Ward, Dr. Kellam sometimes wore his World War I uniform.

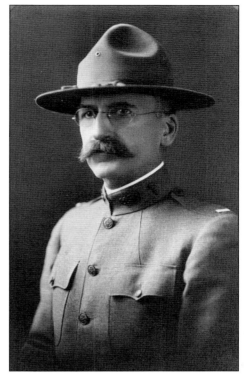

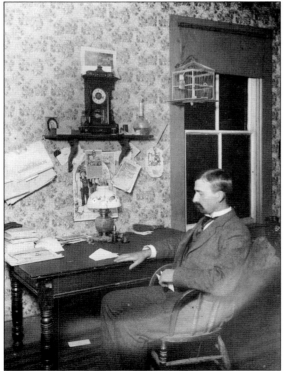

This later image of Dr. Kellam was taken in his office in Port Blakely. While practicing on Bainbridge Island in Kitsap County, he was elected for four terms as county coroner between 1892 and 1900. He was also the owner of Kellam Hot Houses and Ranch near Pleasant Beach. He practiced for 46 years in the Bainbridge Island and Seattle area. His black bag and other instruments used at that time are on display at the Bainbridge Island Historical Museum.

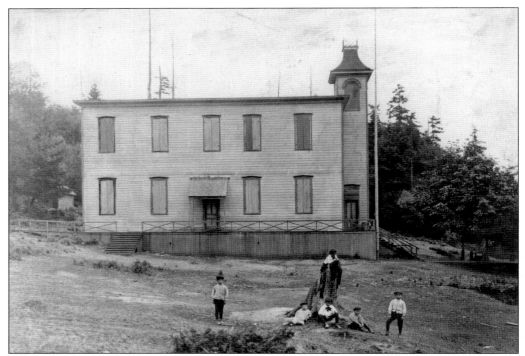

This Port Blakely School was used from 1883 up until 1926. During this period of time, it had the largest faculty and enrollment of all the island schools.

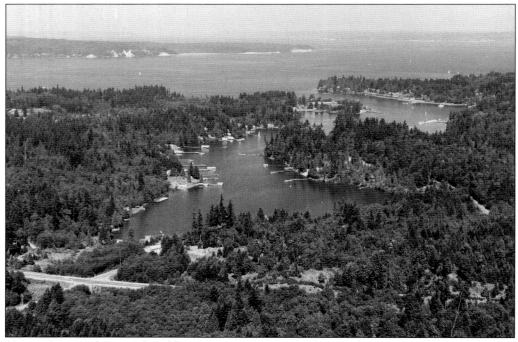

Here is Port Madison and Hidden Cove as they appeared from the air a number of years ago. Note the timber growth at this time.

James W. Hall was the only son of Henry Knox Hall and took over the management of the shipyard in Winslow after his father retired in 1904. He was the last of the Hall shipbuilders.

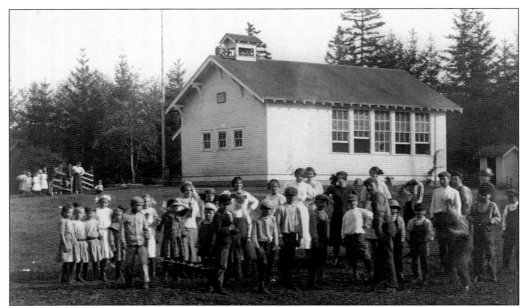

Island Center School, built in 1908, was one of the last one-room schools on Bainbridge Island. The building was moved and last used by the consolidated school district; at that time, it was called the Annex at Bainbridge High School. It was donated in 1971 by the Bainbridge Island School District for use as a museum and moved to Strawberry Hill Park. In 2004, it was moved to the present site to house the artifacts and material of the Bainbridge Island Historical Museum at 215 Ericksen Avenue NE, an easy walk from the ferry dock and downtown Winslow.

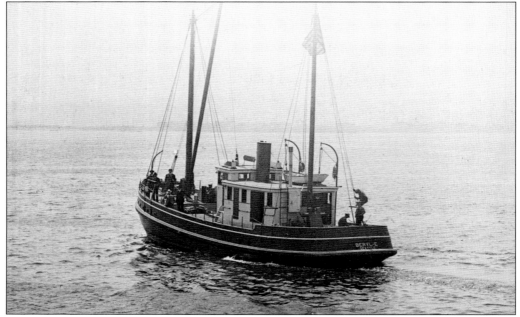

The *Beryl-E* was a Seattle fish tender that worked in the areas around Bainbridge Island, as shown in this 1925 photograph. In more recent years, Guy E. Hoppen of Gig Harbor has owned it. It has a 2,000-gallon fish tank and a wooden hull.

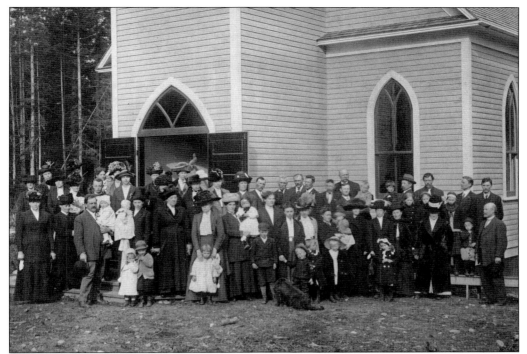

Dedication day was May 19, 1912, for the Port Madison Lutheran Church, after five years of money raising and hard work by the congregation. This church is located at the corner of Madison Avenue and Torvanger Road and is still an integral part of the community today and is considered one of the most beautiful churches around by many who have seen it.

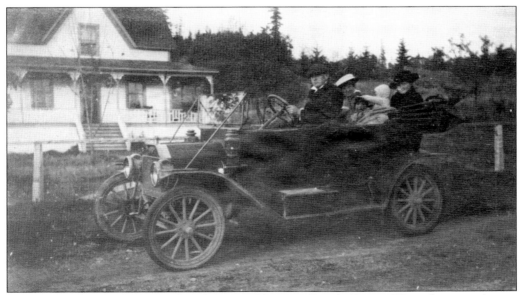

This family is out for a Sunday drive on Pleasant Beach Drive. This photograph was taken about 1915.

Robert Cave was a horticulturist who built his home on the corner of Winslow Way and Ferncliff Avenue, next to the Hall Brothers Shipyard. He was married to Lillian Billings, who was a sister to George E. Billings, for whom one of the Hall Brothers' more famous ships was named. Robert Cave was on the Eagle Harbor School Board for 14 years and was a founding director of the Bainbridge Island Fair Association in 1927.

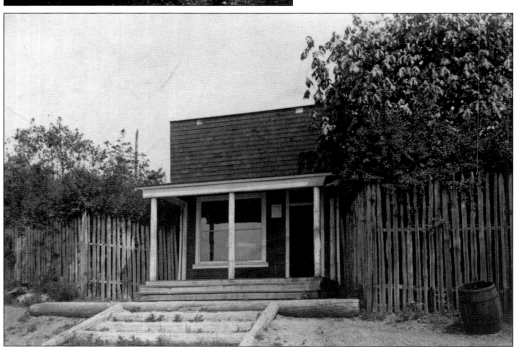

Duncan and Bill Munro ran this grocery store, which their uncle Lachlan Montgomery built, at Crystal Springs in 1909. In 1933, this store was converted into a home for George Munro and his wife.

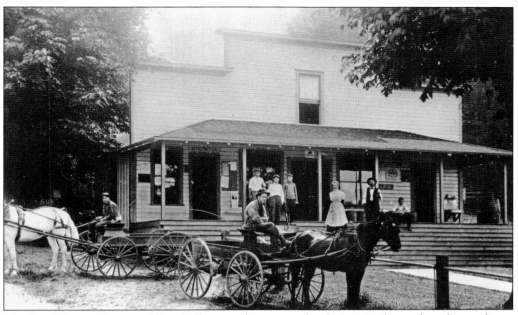

The Port Madison Store and Post Office was the center of early activity, located on the southeast corner of Euclid and Lafayette Avenues, as seen in this photograph taken about 1912. Mr. and Mrs. Frost operated the store, and George Wist was the postmaster.

YOU ARE CORDIALLY INVITED TO
ATTEND A SOCIAL DANCE TO BE GIVEN
AT THE
PROGRESSIVE HALL, WINSLOW
SATURDAY EVENING,
SEPTEMBER 18TH
BY THE PACIFIC PASTIME CLUB
U'REN'S ORCHESTRA

Launch "COMEDIAN" leaves foot Columbia St.
Seattle, at 8 p. m.  Port Blakely, 8:45 p. m.

The Mosquito Fleet made transportation very easy and common for special events around Puget Sound in the early days. This invitation is for a social dance to be held at Progressive Hall in Winslow, and transportation was to be aboard the launch *Comedian*.

Jessie Plate is shown in her Sunday best sitting on a log for this portrait. Her sister Mignon was honored on a cornerstone laid on October 24, 1904, as being one of the 15 women who helped build the Old Port Blakely Presbyterian Church. Unfortunately, Jessie passed away when she was only 19, on February 25, 1904.

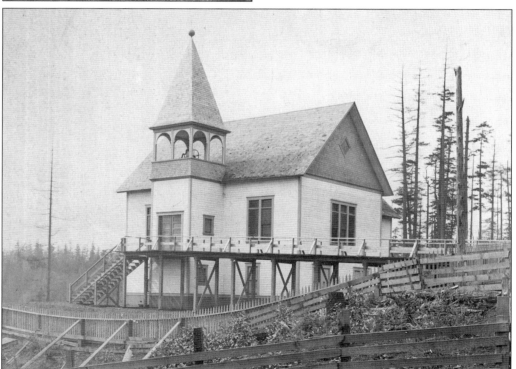

The Port Blakely Presbyterian Church was dedicated on March 19, 1905, only a year after the ladies of Port Blakely met at Effie McConnell's home to initiate talk about raising the money through bazaars and benefits. The mill donated the site and discounted the building materials.

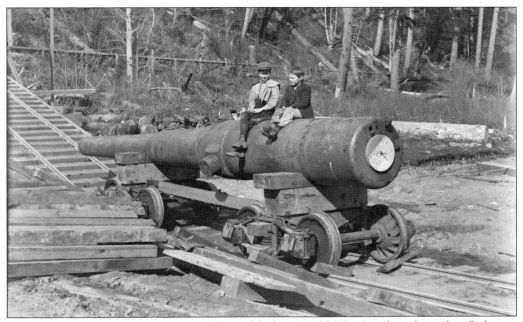

Fort Ward protected the Bremerton shipyard before World War I with eight-inch rifled guns such as these. These 16-ton barrels had to have a narrow-gauge railroad built to carry them and their ammunition up to the top of the bluff. They never had to be fired, except for drills or ceremonies.

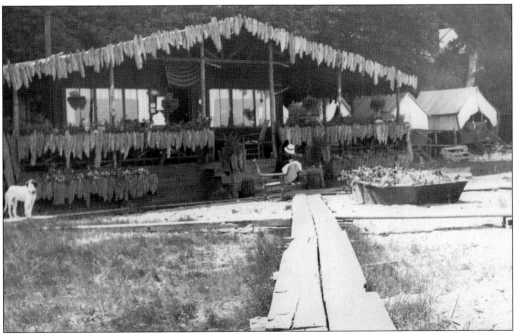

Here is the Young Women's Christian Association (YWCA) Camp Headquarters Building at Yeomalt Point, which operated off and on between 1912 and about 1940. On the eves and deck railings are what appear to be driftwood decorations.

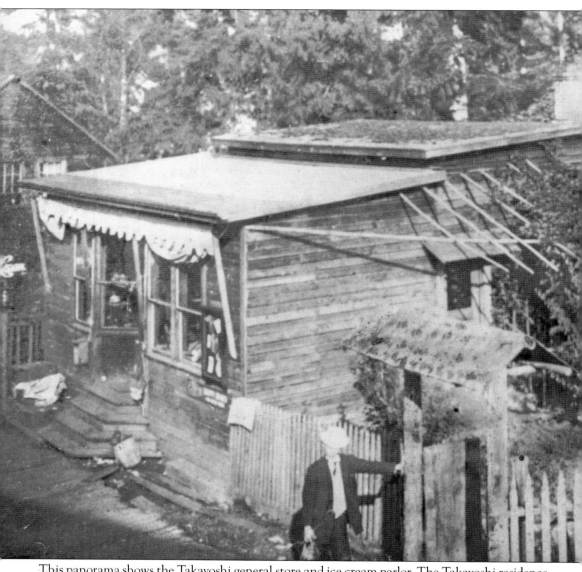

This panorama shows the Takayoshi general store and ice cream parlor. The Takayoshi residence is to the immediate right of this page. Kiyonosuke Takayoshi is shown at the front gate of his

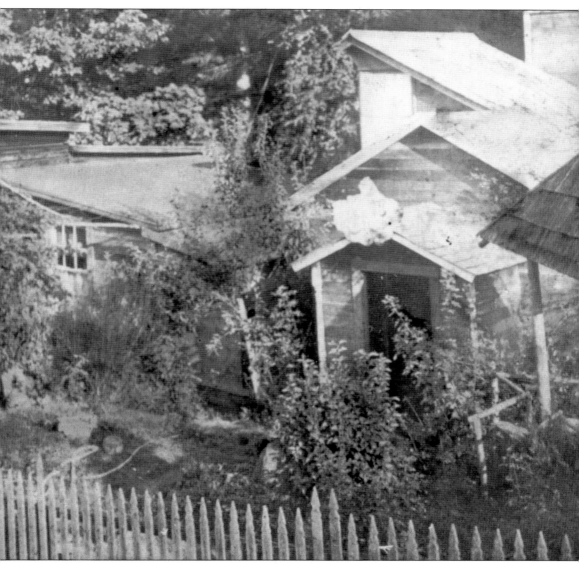

home. In the back of his store was a dance hall where Kimiko, his daughter, played the piano for the dances while at other times an old-fashioned record player provided the music.

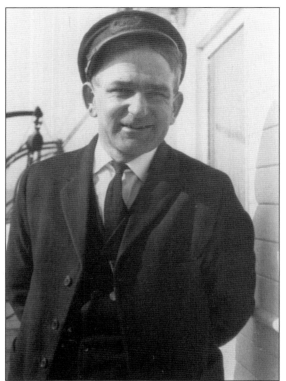

Capt. Alfred E. Welfare Jr. lived all of his life on Bainbridge Island. He was born in 1881 and started his steamboating career at age 13 aboard the *Politkofsky* as a cabin boy. He eventually was to become master of passenger steamers and ferries for Kitsap County Transportation and Puget Sound Navigation. He was the son of Capt. Alfred E. Welfare, who had first settled in Port Madison in 1869, when he found employment in the Port Madison Mill.

This was the second Port Blakely Mill as it looked from 1902 to 1906. This mill, like the one previous to it, would burn down in 1907 to be replaced by another. The third and final mill was eventually dismantled in 1924.

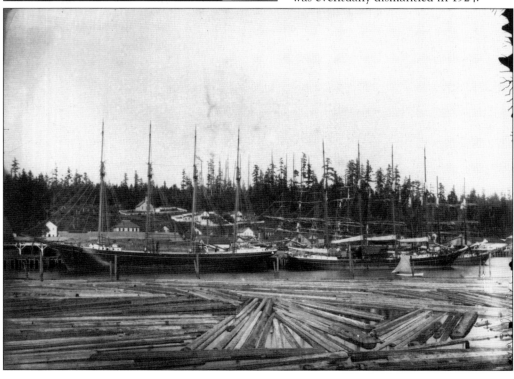

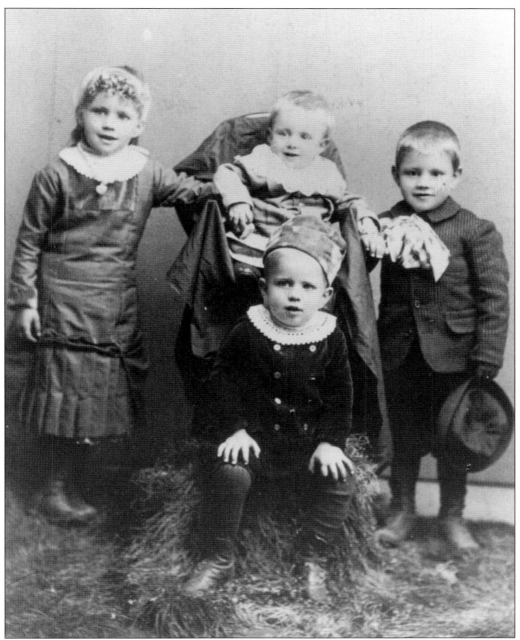

Four of the Joseph and Catherine Raber children were born before Washington became a state in 1889 and attended Island Center School. Arnold A. is shown on the high chair, Carl is seated in the front, Minnie is on the left, and Albert is on the right. Two other Raber children, Anna M. and George W., were born later and also attended school at Island Center. Joseph R. Raber was a veteran of the Civil War.

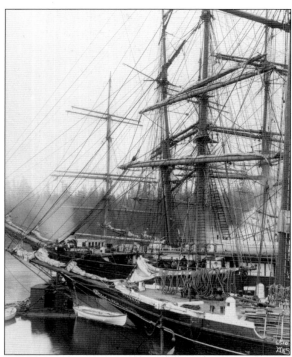

In the foreground is the four-mast schooner *Blakely* next to the German bark *Thalassa*. These schooners are at the Port Blakely Mill wharf in this 1905 photograph.

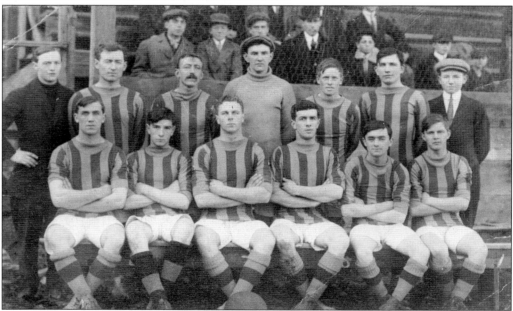

In about 1913, this was the Port Blakely Soccer Club. Pictured are, from left to right, (first row) Victor Larson, Allen Chapman, Henry Peterson, Stanley Chapman, ? Brebne, and Rudolph Dahlgren; (second row in uniforms) Allie Williams, Lawrence Cunningham, Albert Jeffords, Walter Wimblas and Billie McGrath. The two men standing on each end of the second row are unidentified. Among the spectators in no specific order are Roy Dahlgren, Harry Dahlgren, Harold Chapman, and Jordan Williams.

Rasmus and Christiana Solibakke are pictured in Port Madison in 1918. Rasmus was born in Bergen, Norway, on May 25, 1856, and listed himself as a retired farmer and evangelist on his passport application in 1925 to return to visit relatives in Norway. Christiana was also born in Norway but in 1860; she passed away in 1919.

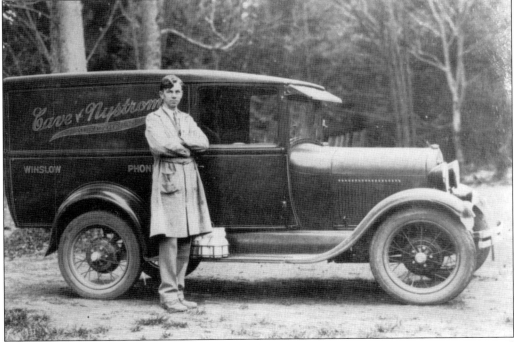

Wilbur Nystrom is standing by a Cave and Nystrom delivery truck. In 1933, Clinton R. Cave and Wilbur Nystrom took over what was originally the first grocery store in the Port Blakely area. Note the milk bottles on the running board ready to be delivered with other customer groceries.

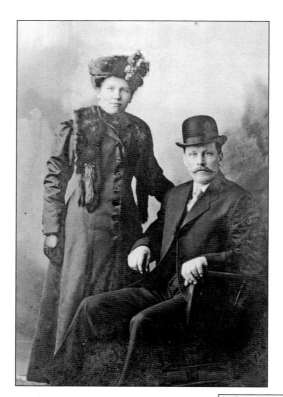

Fred and Florence (or Florene) Jessup came from England; he arrived in 1901 and she in 1909. They were married in Port Blakely on October 1, 1910, and had one daughter, Ethel S. Jessup, who was born on July 11, 1911. By the 1930 census, the family had moved to Tacoma to reside.

Mary Alice Babbitt, born on December 7, 1849, was the second wife of Nathan Bucklin, whose first wife, Marion, passed away in 1874. After their marriage in San Francisco in February 1877, they had six children, Robert Ebe, Frances Lydia, Alice May, Clara, Henrietta, and Emma. Nathan Bucklin was superintendent of the Port Madison mill for 25 years before it closed in 1892.

Edward E. Scott was born on September 27, 1842, and reportedly had the distinction of playing a cornet at Abraham Lincoln's funeral. He met and later married Cordella Ann Scoles, shown below, on March 4, 1864. He was a Civil War veteran. After leaving Illinois, they settled in Madrone (later Winslow), where he used his carpentry skills to help build the Eagle Harbor Congregational Church, schools, and other projects in the area.

Cordella Ann Scoles Scott was active in raising their children with her husband. Edward and Cordella were active in the Congregational church. The Scotts had four children, Minnie, Sarah M., William A., and Delia M.

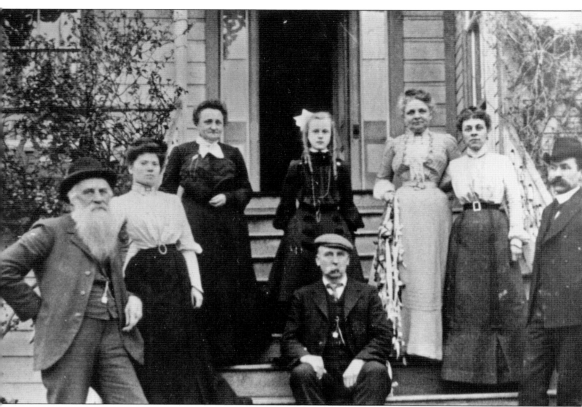

At the launching of the five-masted schooner *George E. Billings* on March 2, 1903, the family attendees were, from left to right, (standing) Henry Knox Hall, Bella White (nurse of the Sander children), Sarah L. Attridge, Elizabeth Sander, Henry Hall's granddaughter Susannah Marie Billings (wife of George E. Billings), Ellen B. Hall Sander (Henry Hall's daughter and wife of Fred E. Sander), and Fred E. Sander. George E. Billings is shown seated at the center.

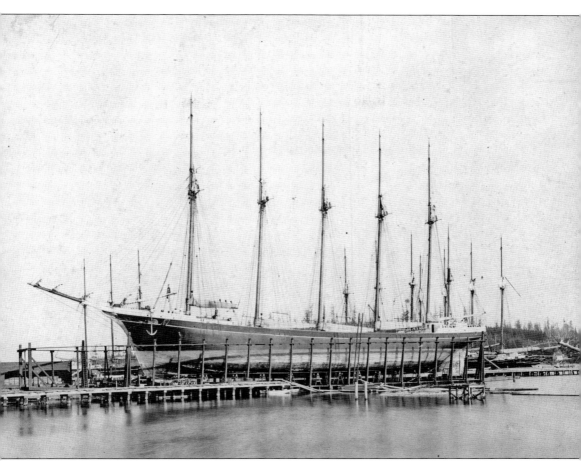

The *H.K. Hall*, a five-masted schooner of 1,237 tons, had the capability of carrying over a million and a half board feet of lumber. It was built by Hall Brothers Shipyard in Port Blakely and launched on May 24, 1902. The *H.K. Hall* was originally built for the Halls' own account for hauling timber, but it eventually sailed under a Peruvian flag and was renamed the *Dante*.

In 1924, Felix A. Narte Sr. came to the United States from the Philippines under less than desirable circumstances aboard a steamship that took about a month to arrive in Seattle due to so many stops along the way. The accommodations on this steamship were very crowded, and the food was not something to look forward to.

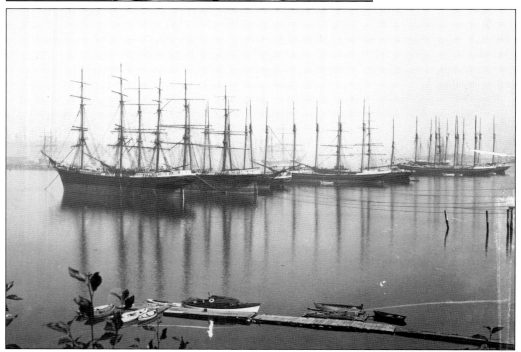

At least 10 sailing ships are shown in Eagle Harbor. The estimated date for this photograph is 1913.

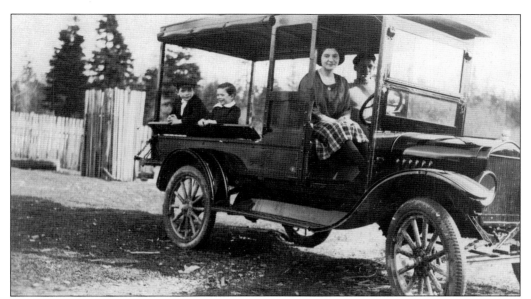

In February 1922, Wilbert Loverich is at the wheel in the Loverich family vehicle with his sister Hilda. Edward (left) and Francis Loverich (right), their younger siblings, are shown in the back. Wilbert attended the first year of Lincoln School in 1908 at Winslow. Thomas Loverich and Christina Cosulich, the parents of these children, were married on September 14, 1903, shortly after Thomas arrived from Croatia.

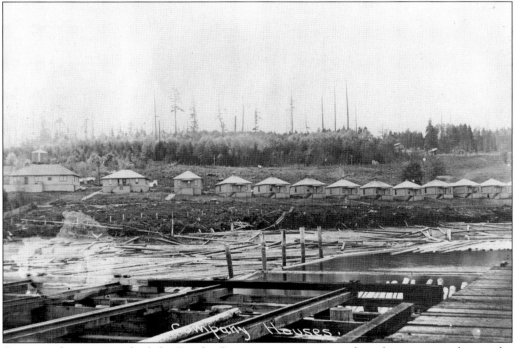

Company houses were built by Pacific Creosoting to accommodate the many employees the company required. Many workers were unable to purchase their own home or land, so they lived in these houses built by the company. They were located a very short walk from creosote plant.

In Yama, near Port Blakely, the Takayoshi store was where most groceries and other sundries were purchased. Posed from left to right in front of the store are Kimiko, Masako, and Yurino Takayoshi.

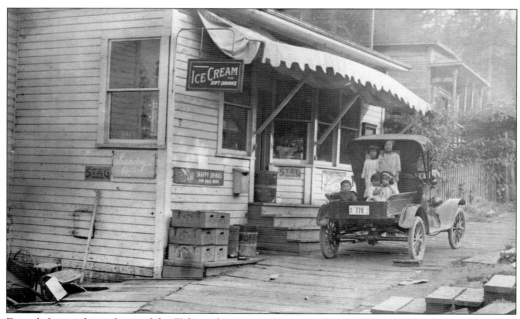

From left to right in front of the Takayoshi store in Yama are (sitting) Taigie, Mariko, and Kimiko; (standing) Masako and Yurino. Note the Washington license plate No. 770 and the ice cream sign on the store.

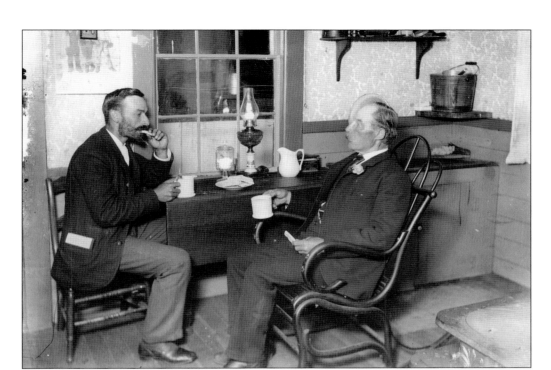

James Hall (left) and an unidentified man are having a discussion about business matters as Charles J. Lincoln takes this picture. Charles J. Lincoln was a well-known photographer on Bainbridge Island and documented many of the historical archives of the area. Charles J. Lincoln attended the Lincoln School in 1908, the school's first year of existence.

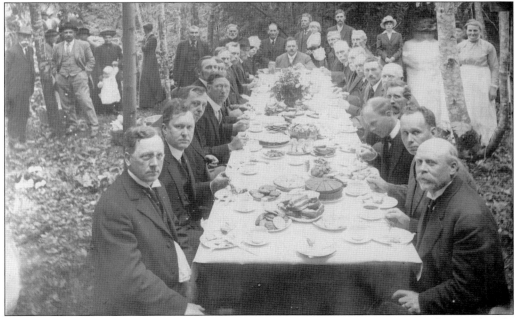

These men seated at dinner are celebrating the dedication of the Port Madison Lutheran Church. The women in picture were the preparers and servers for this festive occasion.

This is a typical Sunday morning scene in Yama, a Japanese village near Port Blakely. This c. 1905 scene shows typical Sunday wear and housing at that time.

# Two

# EARLY BAINBRIDGE ISLAND

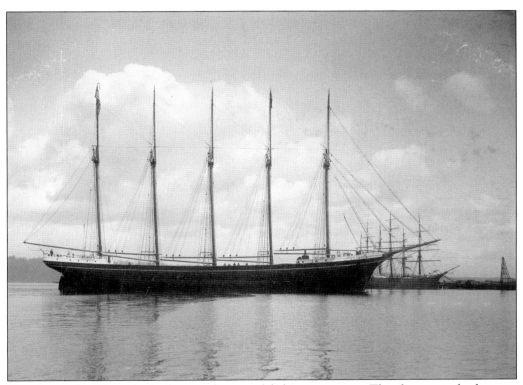

The *George E. Billings* had a long and successful shipping career. This five-masted schooner, built by the Hall Brothers at Port Blakely, was converted into a sportfishing barge after being used successfully for many years to haul lumber all over the world. Eventually, in 1941, it was purposely burned in the water and sank. The *H.K. Hall* and the *George E. Billings*, both built by Hall Brothers, were two of the largest sailing schooners on the West Coast in their era.

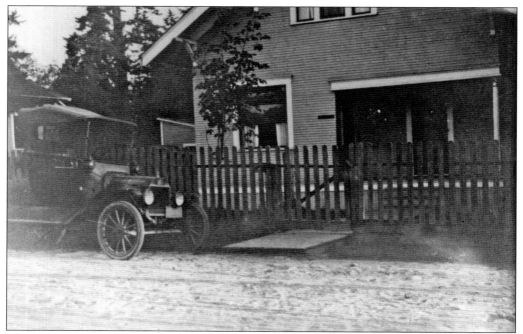

Dr. Frank Shepard's 1914 Model T is shown here where he had his first home and medical practice. A photograph of him and the newer home he built in 1922 are shown on page 60.

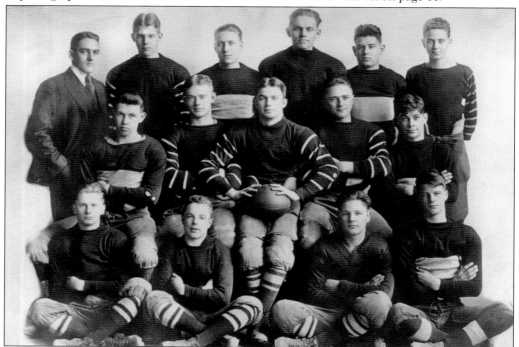

This is the 1924 Moran School football team; the team's coach is wearing a suit. Moran School for boys was established in 1914 and closed on Bainbridge Island in 1933. The facilities later become the Puget Sound Naval Academy.

Ida Lewis Thacher (left) and Betty Troll Munro (right), teachers at the Pleasant Beach School, are shown in this 1929 photograph. This school served the needs of Pleasant Beach students from 1910 until it closed in 1949. Betty Munro was to become the mother of Ralph Munro, Washington's secretary of state for 20 years.

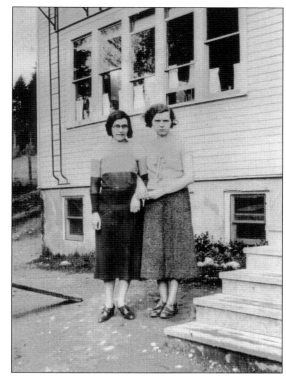

This photograph, taken on August 15, 1918, is of a dry dock at Eagle Harbor. It is described as "Pontoon No. 2." Note the opposite shore is visible.

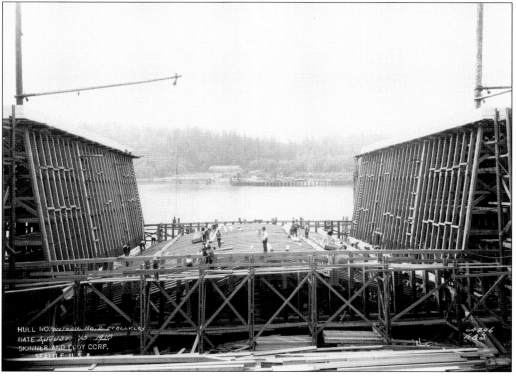

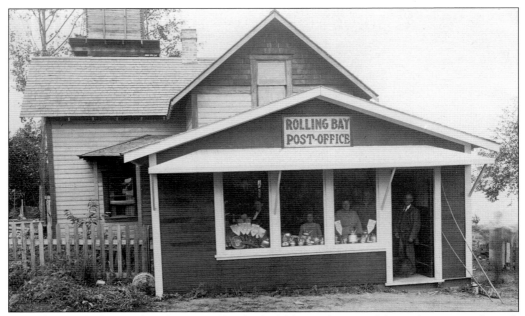

In Rolling Bay, this is what the post office looked like in the period from about 1902 through 1915. This post office was in a store run by Charles Carlsten at the top of a bluff above the Rolling Bay Dock.

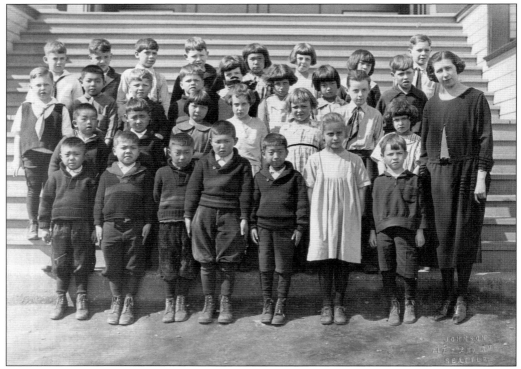

This is an elementary class at the third Winslow school, as it appeared about 1924–1926. Miss Edlgerly was the teacher of this well-diversified class at that time.

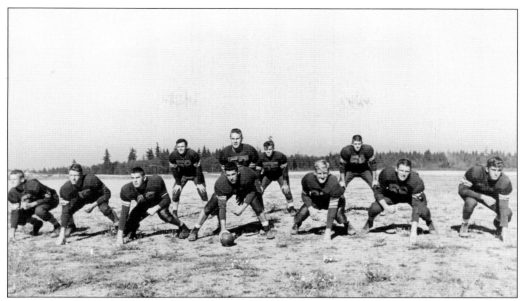

The 1949 Winslow football team, coached by Thomas Paski, won two games and lost six to finish fourth in the league. The linemen are, from left to right, Clemens Kampe, Brian Stafford, George Hahn, Jeremy Peterson, William Orr, Robert Kutz, and Raymond Lowrie.

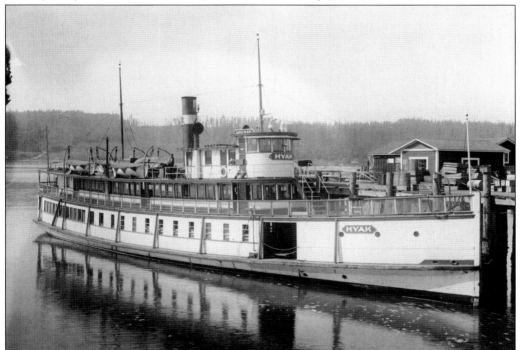

The Mosquito Fleet steamer *Hyak* was built in Portland, Oregon, in 1909 for the Kitsap County Transportation Company. It was 134 feet long and was rated at 195 tons. *Hyak* served on routes running from Seattle to Bainbridge Island and the Poulsbo area. It was abandoned on a mud flat on the Duwamish River in 1941.

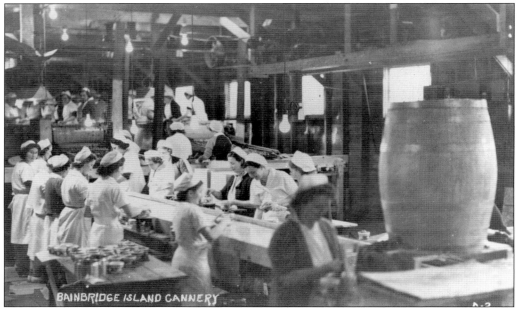

Pioneer farmer Shinichi Moritani grew the first strawberries on Bainbridge Island in 1908. This eventually developed into the Winslow Berry Growers Association, which built a cannery on a dock at the end of Weaver Road on Eagle Harbor.

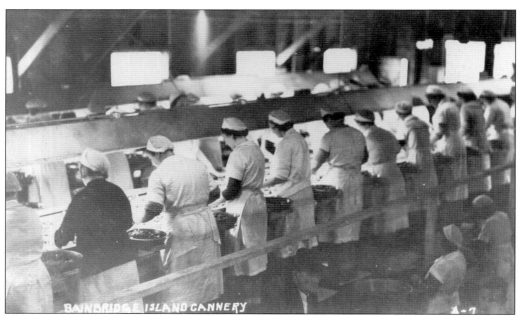

By 1940, two hundred cannery workers were processing about two million pounds of berries that were being shipped throughout the United States. The forced 1942 evacuation from Bainbridge Island of Americans of Japanese ancestry interrupted the berry farming and ended berry packing at the cannery. The annual Bainbridge Island Strawberry Festival is still held by the Filipino community every year to this day.

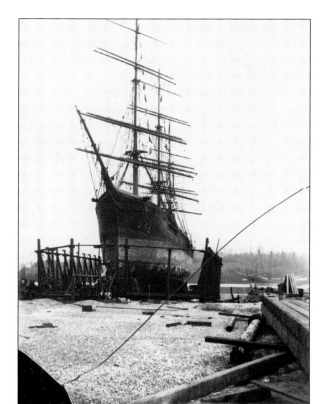

One of the first ships to use Hall's marine cradle in 1903 was the *Reuce*, as seen in the photograph at right. Shown in the photograph below is a bull-wheel and chain-link assembly that would pull the cradle ashore with the boat on it. Each link in these chains weighed 35 pounds.

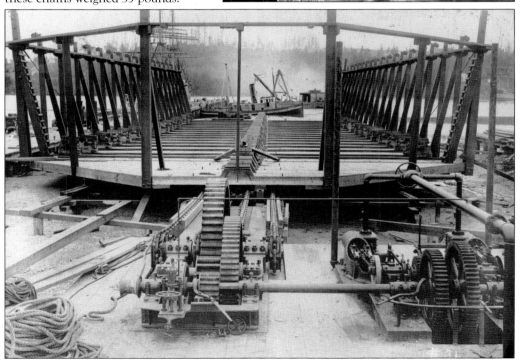

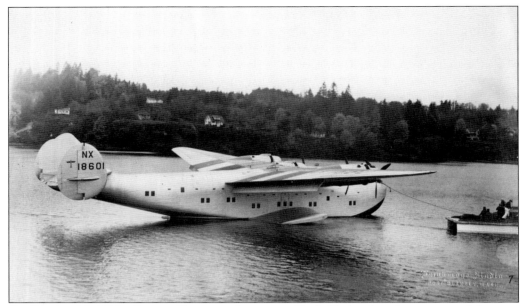

On October 26, 1938, a Boeing Clipper made a visit to Eagle Harbor for what was one of the most unusual dockings in its history. This Boeing Clipper flying boat was hauled out of the water for some of its final Civil Aeronautics Administration certifications.

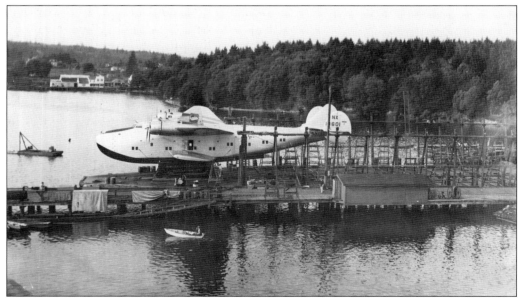

The Boeing Clipper is shown on the marine railway to be weighed. These flying boats were built without landing gear and had to be brought to shore with a marine railway. Boeing built 12 of these B-314s for Pan American Airways between 1938 and 1941.

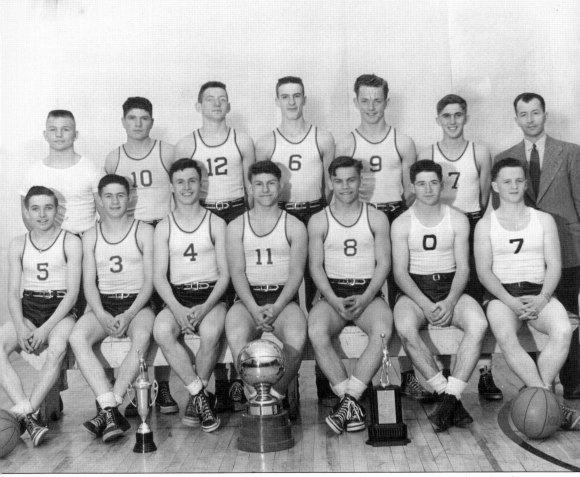

The 1947–1948 Washington Basketball State "B" champions from Winslow High School are shown with their trophies. The team members are, from left to right, (first row) Robert Sigle, Robert Buchanan, Dale Wallace, Donald Nadeau, James Nadeau, Donald Barnes, and Samuel Clarke; (second row) Robert Dixon, Peter Uglesich, Robert Woodman, Jack Start, Robert Olsen, Raymond Lowrie, and coach Thomas Paski.

Dr. Frank Shepard came to Bainbridge Island in 1911, after graduating from Northwestern University Medical School. He was the first resident to have an automobile, a 1914 Ford Model T. Sometimes, he had to find a tug or fishing boat in the middle of the night to rush a patient to a Seattle hospital. He was one of the initial councilmen of the Town of Winslow when it was incorporated.

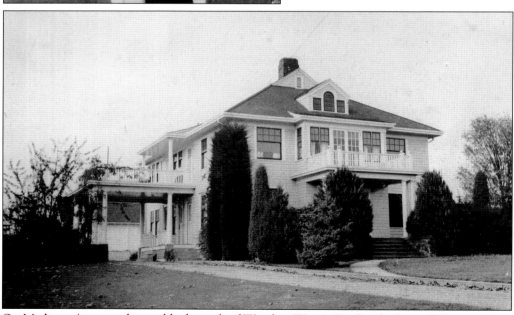

On Madison Avenue, about a block north of Winslow Way, is Dr. Frank Shepard's home, where he had his practice. This home was originally built in 1922 and was most recently converted into offices and moved closer to the street.

The Winslow Hotel, a favorite luncheon spot for shipyard workers, looked like this about 1918. The hotel, on Winslow Way, burned down in 1924.

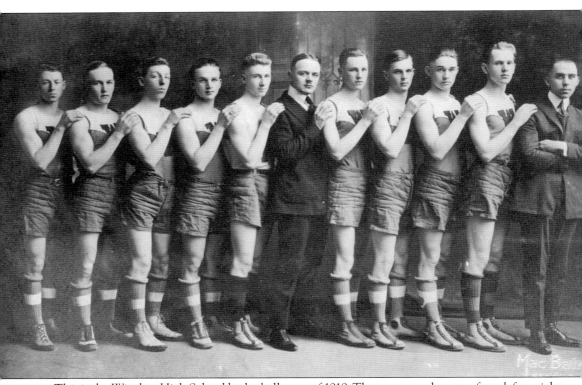

This is the Winslow High School basketball team of 1919. The team members are, from left to right, Vernie McKenny, James Murray, Clinton Cave, Robert Bucklin, William Garthley, Homer Kennett, Paul Oliver, Kenneth Voight, Erling Ericksen, Raymond Parfitt, and George Edenharter.

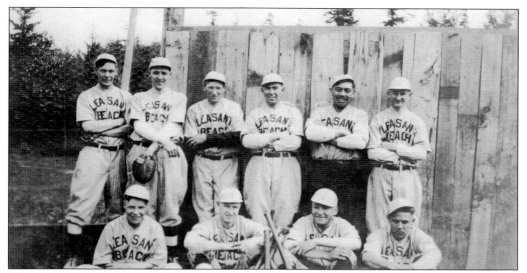

The Pleasant Beach baseball team was located at the southwest corner of Blakely Avenue behind the old Lindquist store. This team of senior leaguers played in communities all over Bainbridge Island.

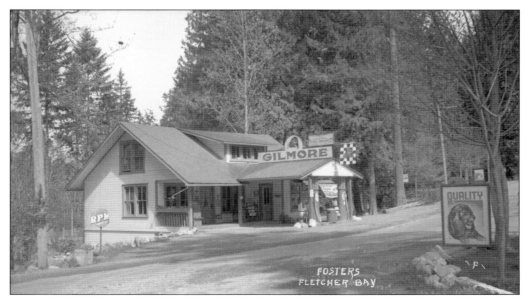

Here is the Fosters Fletcher Bay and Gilmore Store as it appeared on March 25, 1927. This Flying Red Horse service station featured Lions Head Motor Oil, a product of the Gilmore Oil Company.

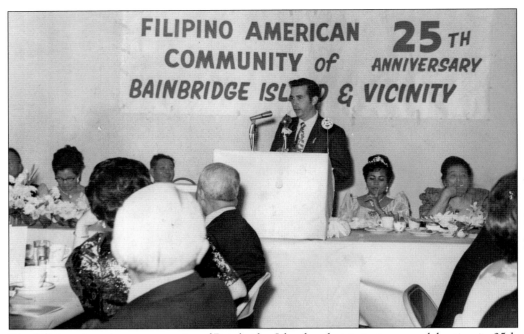

The Filipino American community of Bainbridge Island and vicinity is seen celebrating its 25th anniversary. This event took place in 1968, and the community remains strong in 2013.

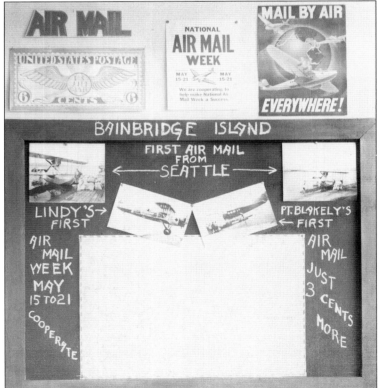

Airmail actually flew to and from Port Blakely on Bainbridge Island during a special promotion for airmail during the week of May 15–21, 1938. This poster board was advertising the event when airmail was only 3¢. Regular service was never established.

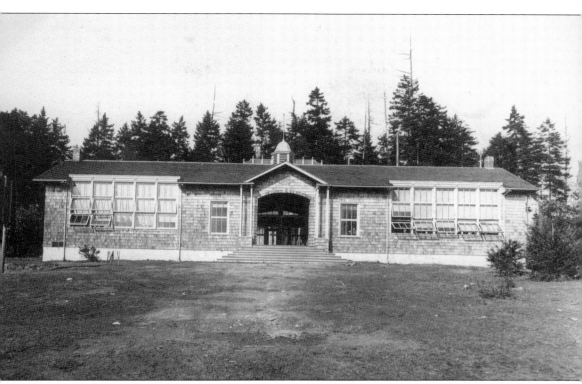

This is the third Rolling Bay School located on "School Hill." It was eventually abandoned in 1929 and demolished in 1941.

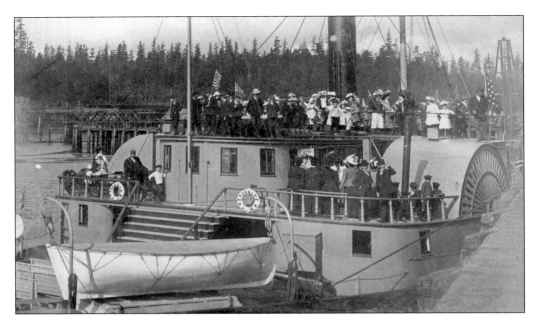

In 1908, the Great White Fleet visited Puget Sound and the Seattle area on its worldwide tour. The Bainbridge Island folks in these two photographs are aboard the SS *Favorite* to greet the fleet on its visit. The 12 majestic fighting ships and their anchoring in the harbor made by far the most imposing pageant ever witnessed in the Pacific Northwest up to that time. The SS *Favorite* was a 60-foot, propeller-driven vessel, built in Astoria, Oregon.

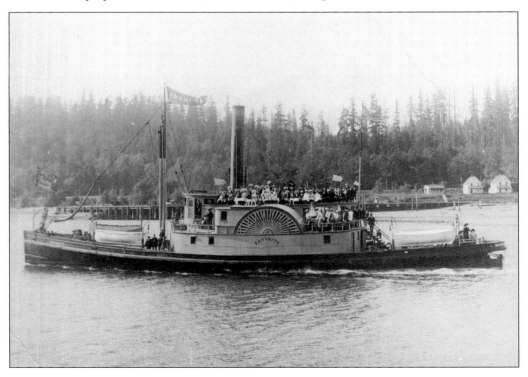

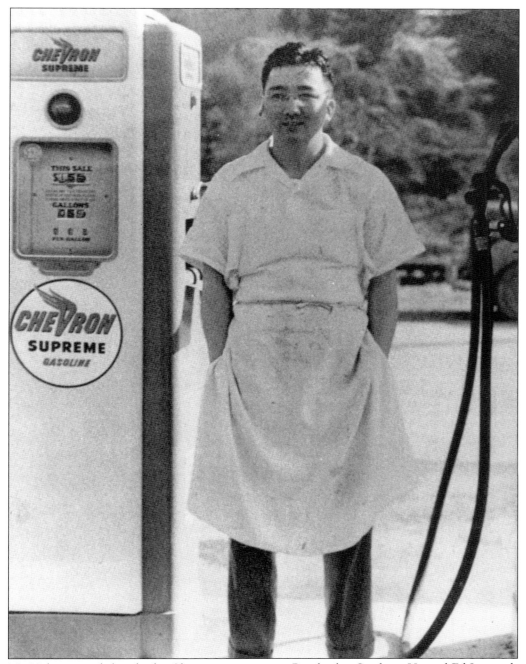

Mo Nakata stands beside the Chevron gas pump at Bainbridge Gardens. He and Ed Loverich leased Bainbridge Gardens for a time from Zenmatsu Seko and Zenhichi Harui, who established the gardens in 1910. Nakata was to eventually earn both a Bronze Star and a Purple Heart for his service in World War II.

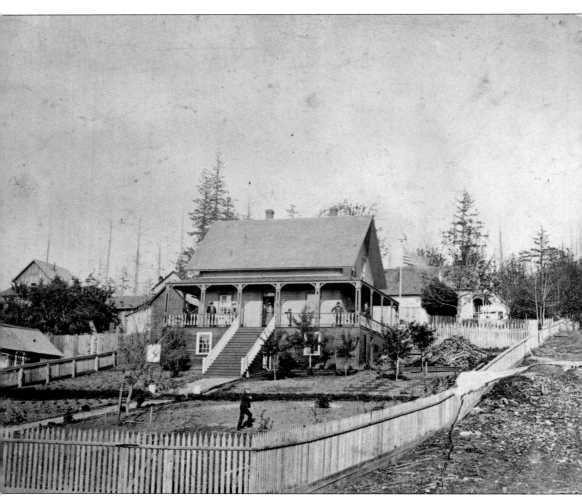

The home of Capt. John and Helen Farnham in Port Madison was once said to be the center of informal social life in the area. Captain Farnham first went to sea from Charleston, South Carolina, in 1832 at the age of 12. He came to Puget Sound in 1865 to work at the Port Madison Mill commanding the *Phantom*, *Ruby*, and other steamers. After he retired about 1897, he and Helen moved to Seattle.

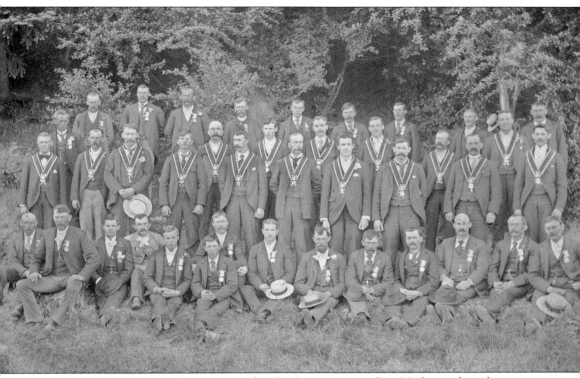

The Kane Free and Accepted Masonic Lodge No. 8 was active in Port Madison when this group photograph was taken about 1880. Around 1874, George E. Meigs donated the land to the community for the Kane Cemetery; his nine-year-old son died in 1870.

Port Madison Store and Post Office was a company store and was more than a general store in the usual sense. It was the only facility to supply the needs of the workers in the Port Madison mill.

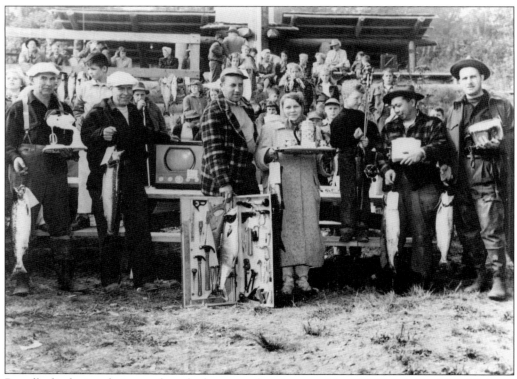

Proudly displaying their awards and salmon are the winners of the 1950 Bainbridge Island Salmon Derby. Pictured are, from left to right, Bert Linquist (Mixmaster), Thor Anderson (television), John Mikola (tool set), Vera Anderson (tea set), Sam Nakoa (toaster), and unidentified winner and his prize to the far right.

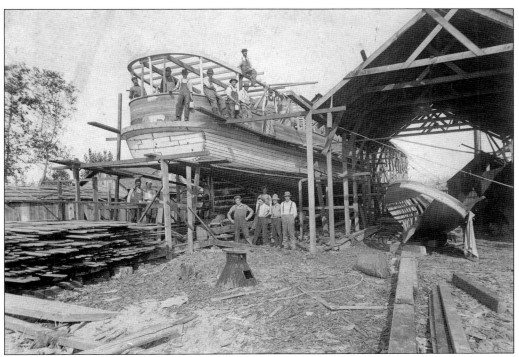

Houseboat *Lotus* is being built in the Winslow shipyard about 1915. Houseboats are quite common around Puget Sound as an alternative to waterfront property.

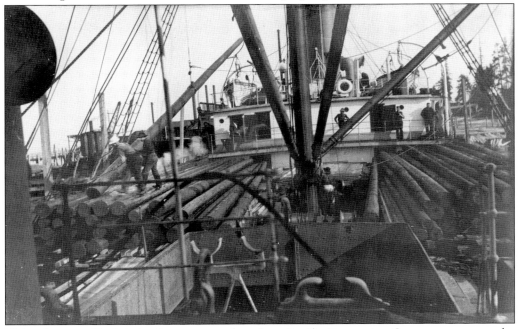

This schooner, *Cecil*, is loading creosote logs from Pacific Creosoting Company to go to the Panama Canal. This creosote treating plant shipped creosote logs worldwide, even to Vietnam during the war there.

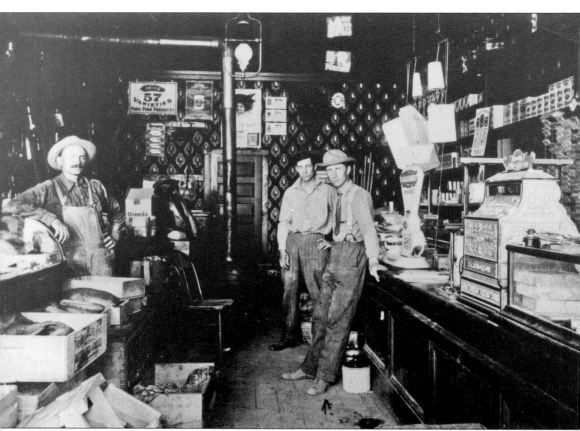

These three men are shown inside the Madrone Store on the Eagle Harbor dock at the foot of Madison Avenue. The owner of the store, Percy Henderson, emigrated from England around 1900.

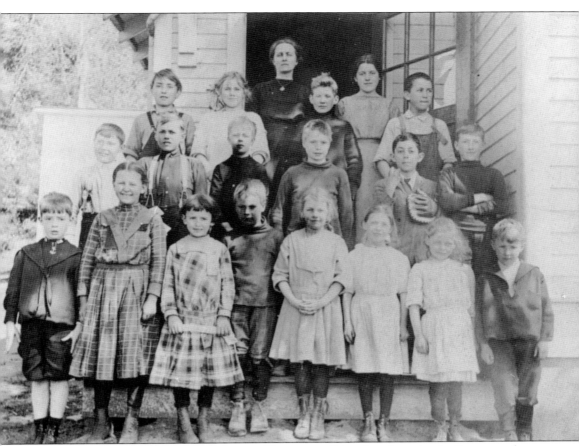

This 1910 image shows the Crystal Springs Elementary School students in the first year after a remodeling of their school due to increased enrollment. All of the seats faced the bay, and the lighting in the winter months was by kerosene lamps. The teachers were paid $60 a month at this time. Pictured are, from left to right, (first row) Allen Greenough, Connie Edenharter, Rose Edenharter, Ernest Kronholm, Margaret Garthley, Euphemia Munro, Isabel Munro, and Willie Hansen; (second row) unidentified, Harry Hansen, Allen Oakes, Edgar Kronholm, Fred DeSota, and Bill Garthley; (third row) Willie Price, Jeanne Hansen Cook, Hanna Tvete (teacher), George Munro, Marie Duckjose, and George Edenharter.

The McDonald School was originally built in 1905, added onto in 1913, strengthened in the early 1940s, and eventually closed in 1965. Malcolm McDonald, who was the manager of the Port Blakely Hotel and also owned the Pleasant Beach Hotel and Pavilion, gave the land to the people of Eagledale for a school, and for his generosity, they named it after him.

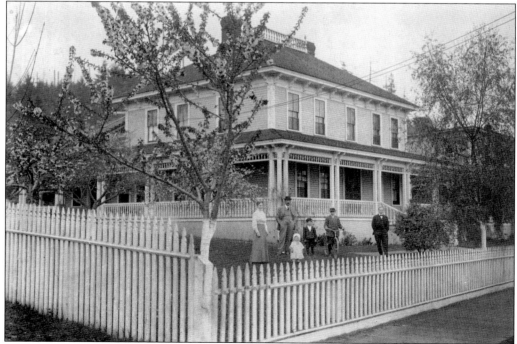

James and Hattie Rucker moved to this residence from Hoquiam about 1907, while the Port Blakely sawmill was being rebuilt after being destroyed by fire in 1907. Rucker was the superintendent at the sawmill in Hoquiam but returned to Blakely to oversee the rebuilding of the sawmill. He passed away in 1915 at the age of 47.

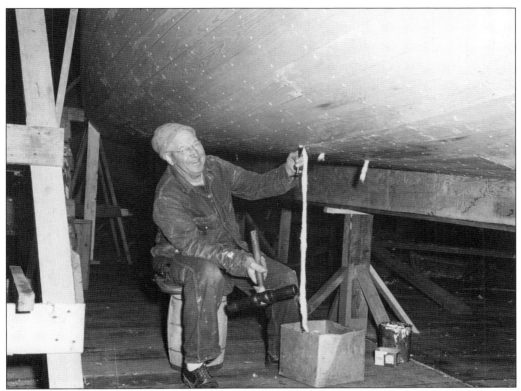

Cecil L. Foss is showing his master carpenter and building skills caulking the *Cindy F.* Foss was a World War II veteran, and after the war, he established a boat business, which he sold in 1978.

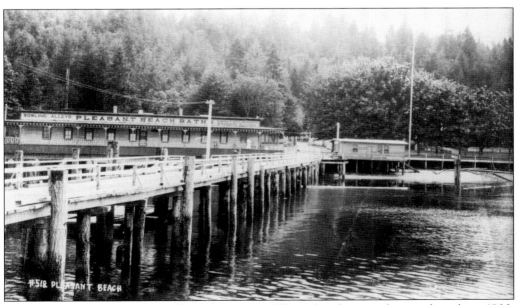

Pleasant Beach was originally called Sylvan Cove. When this photograph was taken about 1900, Malcolm McDonald owned it, and it was complete with saltwater baths and a bowling alley.

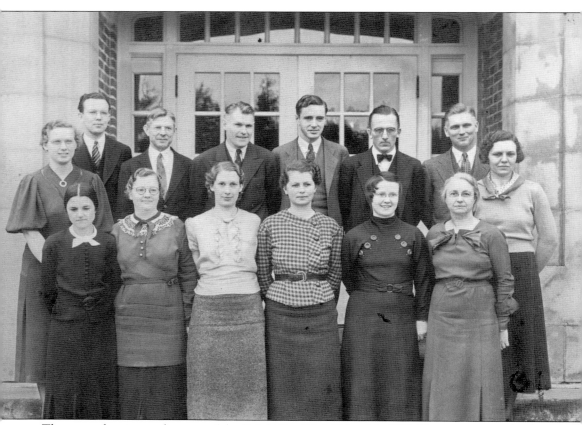

These people pose on the steps of the Bainbridge High School in 1931. The cornerstone for their new high school was laid on July 27, 1927. It was ready for occupancy on January 1, 1928.

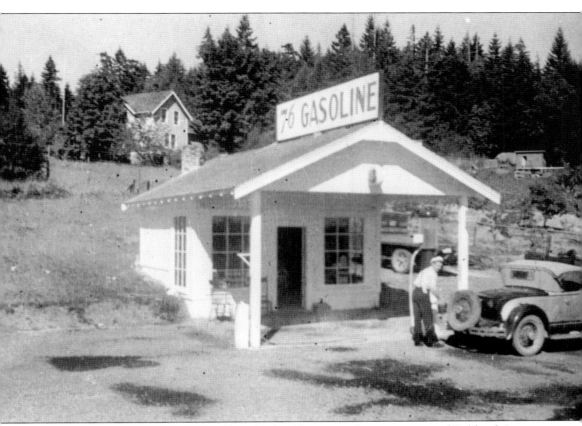

Here is an early 76 gas station owned by Charles Olson near the intersection of Birkland Avenue and Blakely Road. The Birkland house is shown in the background.

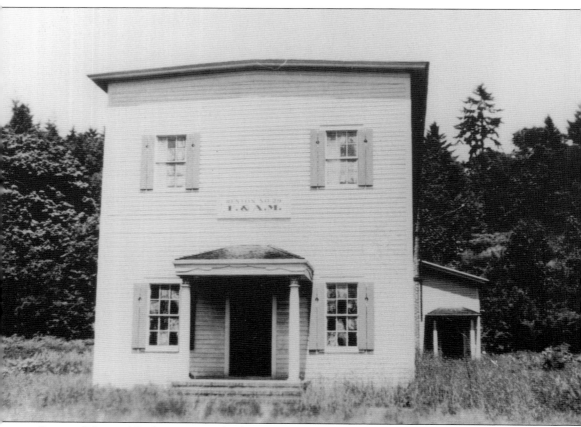

Renton (Masonic) Lodge was named to honor Capt. William Renton, who encouraged the formation of a lodge at Port Blakely and erected a building for the group's use. This lodge originally received its charter on June 5, 1879, with the following charter members: William T. Brown, John A. Campbell, John Corbell, Eugene G. Chenell, Alex Dumas, M.H. Duane, James C. Eschen, George Hewitt, George Leveny, James O'Brien, Joseph W. Phillips, Warren D. Ray, Charles Robinson, Daniel Richards, Eagle C. Sanders, and Charles S. Swanberg. The lodge pictured here burned to the ground on November 14, 1955. All that remained was the master's chair, which had been brought around Cape Horn on a sailing ship.

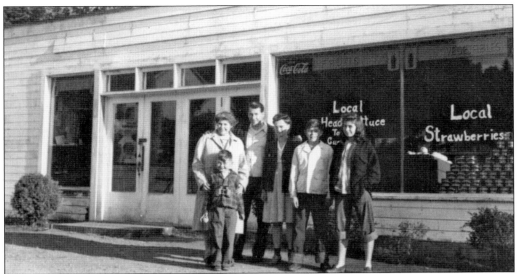

Shown in front of Judd's Market in 1946 are, from left to right, Judd's sister, Cubby Nusslock, with her son Richard (front); George J. Huney; Alice Huney; and Elizabeth and Mary Nusslock. Judd and his wife, Alice, opened their first grocery store at Pleasant Beach in 1945. In 1947, they bought the Lynwood Grocery Store, which they later sold, and then started a coin-operated dry cleaning business.

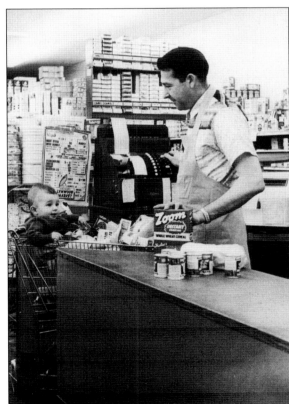

George Judd Huney is shown at the cash register at what was Judd Huney's Lynwood Grocery. Judd later worked as a meat cutter for John and Mo Nakata at Thriftway until he retired in 1978. Judd Huney was very active in Bainbridge Island civic affairs all during his career.

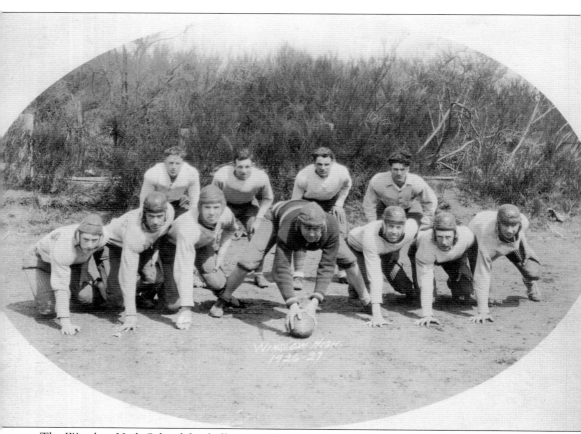

The Winslow High School football team of 1926 is pictured above with leather helmets. Shown from left to right are (first row) Melvin Case, Harold Englund, Hayden "Skinny" Callahan, Mark Antoncich, Henry Larson, Erlin Logan, and Peter Antoncich; (second row, backfield) Ronald Bucklin, Glenn Reeve, Charles Owen, and Earl Callahan.

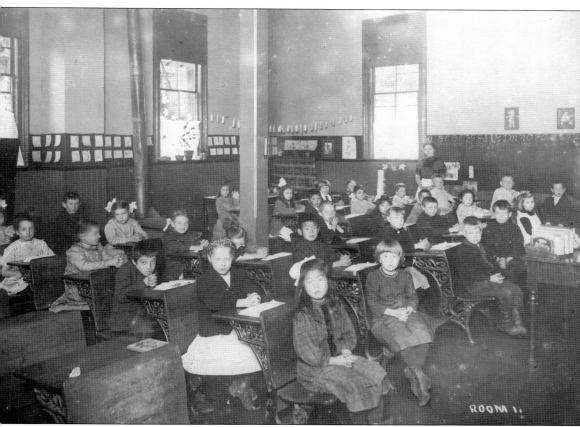

This early picture at Port Blakely School shows 30 well-mannered students posing for the photographer with their hands folded. Port Blakely School District No. 5 was different from most other districts in the area at that time because the mill owned the land, paid the teacher's salary, and furnished the equipment.

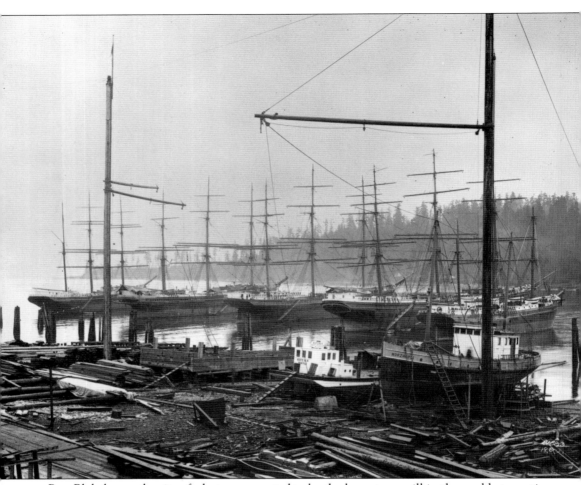

Port Blakely was the site of what was reported to be the largest sawmill in the world at one time. These sailing ships are evidence of the activity surrounding the mill in the early days.

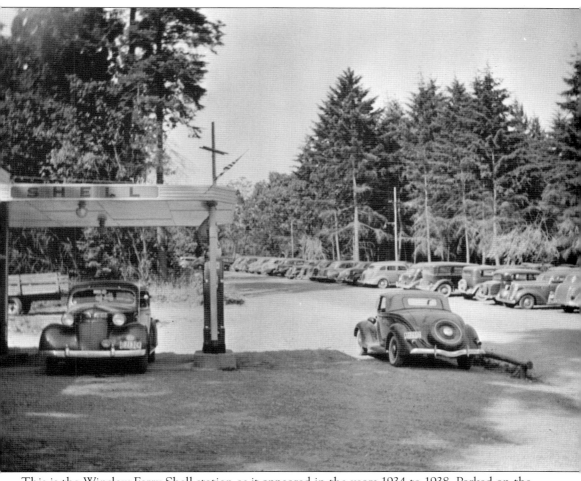

This is the Winslow Ferry Shell station as it appeared in the years 1934 to 1938. Parked on the right-hand side are the cars of foot passengers taking the ferry.

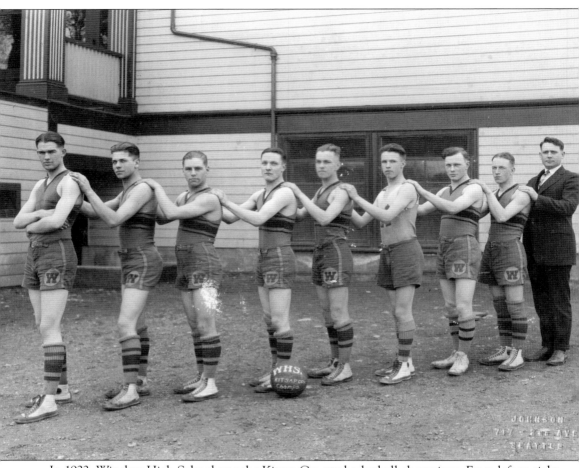

In 1922, Winslow High School was the Kitsap County basketball champions. From left to right are Reider "Ray" Erickson, Elmer Johanson, Ray Stebbins, Edward Wallace, Henry Johanson, Rick Soderland, Chalmers Wallace, Earl Callahan, and E.M. Draper, coach.

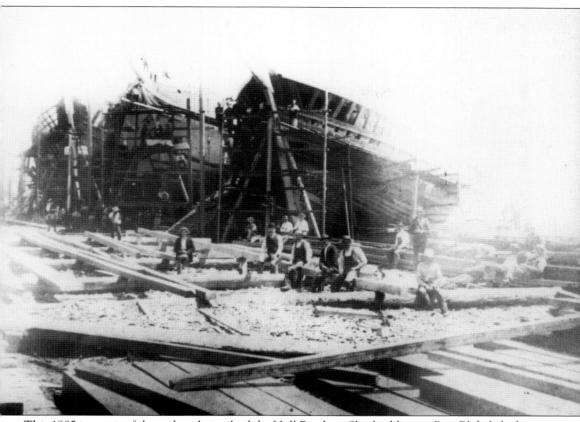

This 1885 image is of three ships being built by Hall Brothers Shipbuilding in Port Blakely before moving the shipyard to Eagle Harbor. Between the years 1881 and 1903, the Hall brothers, Isaac and Winslow, built 77 sailing ships at Port Blakely.

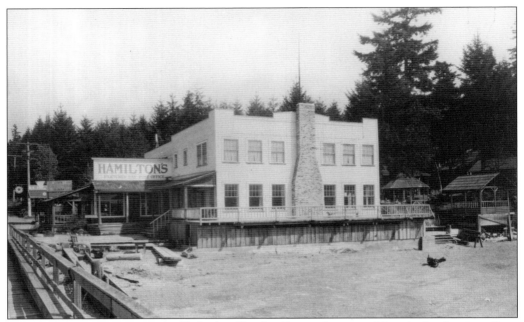

In 1912, Foster's Resort was established at Fletcher Bay and attracted hundreds of visitors from the mainland. Mr. and Mrs. Ray Hamilton took over the pavilion from the Fosters in 1927 and called it Hamilton's Fletcher Bay Resort. This is the first Hamilton's Fletcher Bay Resort before the fire on July 18, 1932, that completely destroyed it.

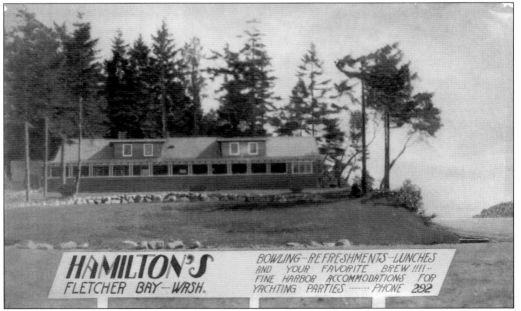

A new Hamilton's Fletcher Bay Resort was rebuilt after the fire and appeared as above complete with a new bowling alley. A post office operated from this location from 1915 until 1936.

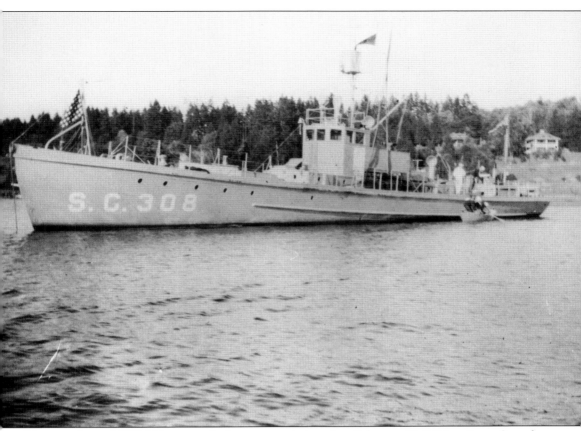

This naval vessel (SC-308) was a sub chaser commissioned on February 23, 1918, at Puget Sound Naval Shipyard. It was 110 feet long and was seen in the Bainbridge Island area on patrol during World War I. This sub chaser was sold to M. Levin and Sons of San Francisco, California, after the war on September 22, 1922.

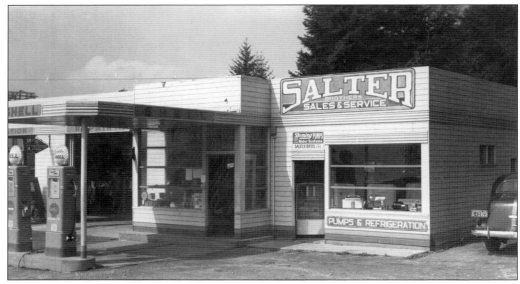

James and William Salter, who attended Rolling Bay School, ran Salter Brothers Sales and Service. This photograph was taken about 1938.

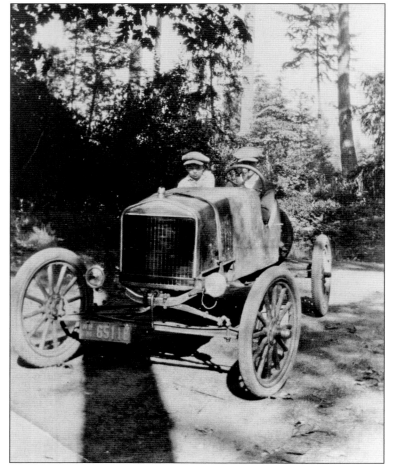

James and William Salter are shown with their old homemade 1925 Model T "Bug" near Manitou Beach. They would eventually be partners in Salter's Sales and Service, shown at the top of this page.

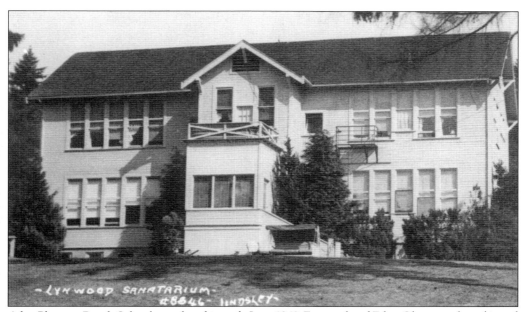

After Pleasant Beach School was closed in early June 1949, Emanuel and Edna Olson purchased it and converted it to a rest home, the Bainbridge Sanitarium. Later, it was called Serenity House.

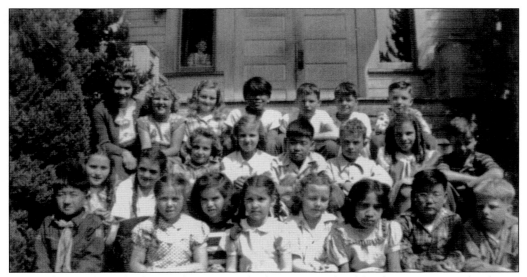

This is the fourth-grade class at Pleasant Beach Elementary School for the 1948–1949 school year. From left to right are (first row) Masaru Shibayama, Karen McCormic, Lyla Oakens, Mary Shepherd, unidentified, Joyce Rapada, Frank Kitamoto, and Warren Nadeau; (second row) Beverly Durrell, Jean Williams, unidentified, Paula Eason, Neal Hayashida, Bob Ostrand, Marilyn England, and Joe DuPaul; (third row) teacher Alice Klingbeil, unidentified, Ardath Sutherland, Jerry Elkins, Richard Bucklin, Thomas Thatcher, and Ron Denton.

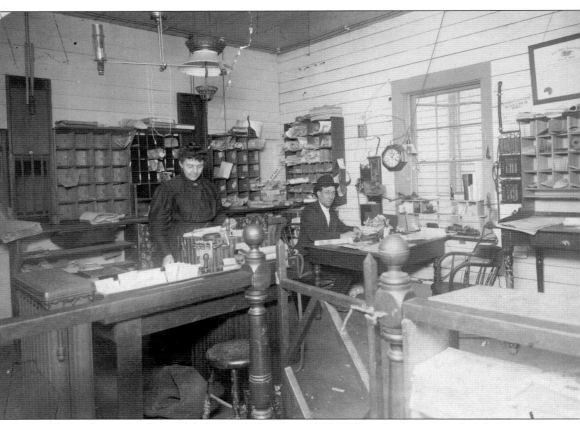

Here is the inside of Port Blakely Post Office about 1890. William R. Renton was listed as postmaster from January 17, 1872, through December 31, 1890, probably partly due to his ownership of the mill. The individuals in this photograph are unidentified.

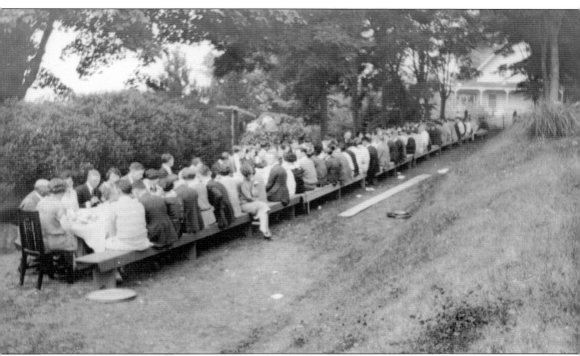

Employees of the Dexter Horton Bank of Seattle are having their annual summer picnic at the residence of Norvel H. Latimer, an 18-room mansion called Norvel Hall. He was the president of the bank, the predecessor to Seattle First National Bank, which was later purchased by Bank of America. Eventually, the bank took over the home for bank employees to use as a retreat, and Latimer had to move out. It burned down in 1929.

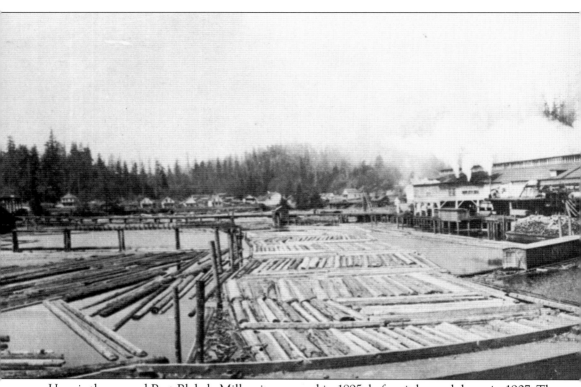

Here is the second Port Blakely Mill as it appeared in 1895, before it burned down in 1907. The first mill burned down in 1888. Port Blakely was one of the busiest and most thriving towns on

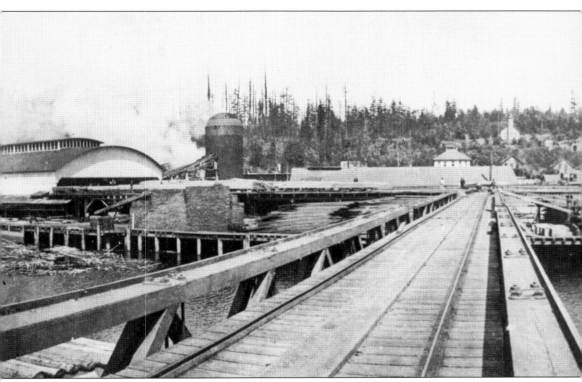

the Pacific Coast at this time. This mill would cut 500,000 board feet of lumber per day.

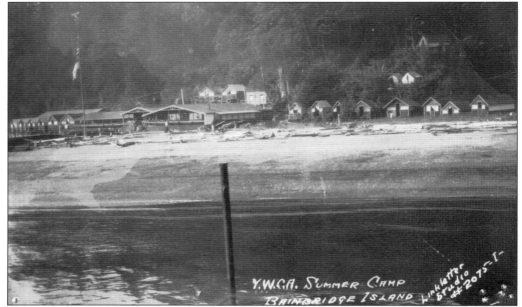

The YWCA bought 18 acres of land north of Yeomalt Point and operated a camp there from 1912 until it was closed in the 1930s due to the Depression. It was used as a summer camp for both families and girls. There was a Boy Scout camp nearby.

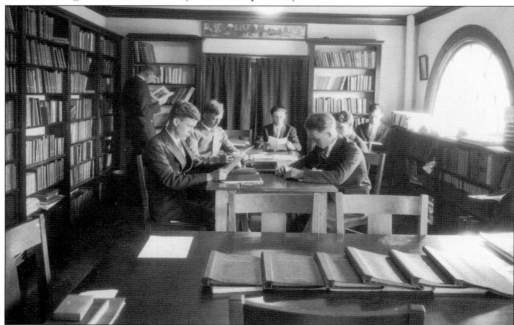

These students are studying in the library of Hill's Puget Sound Naval Academy at Skiff Point, near Rolling Bay, about four miles north of Winslow. This academy operated from 1938 to 1951 and was for students aged 12 to 18 in preparation for the US Naval Academy at Annapolis or the US Coast Guard Academy at New London. Today, many of the facilities have been converted and are being used by the Messenger House Care Center as a privately owned skilled nursing facility.

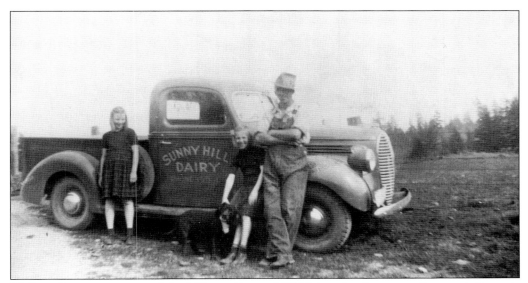

William Peterson, owner of the 160-acre Sunny Hill Dairy, also known as Peterson's Farm, is shown with his two daughters, Judith on the left and Dorothy on the right. Peterson was born in Port Blakely and was operating the farm when this photograph was taken in 1940.

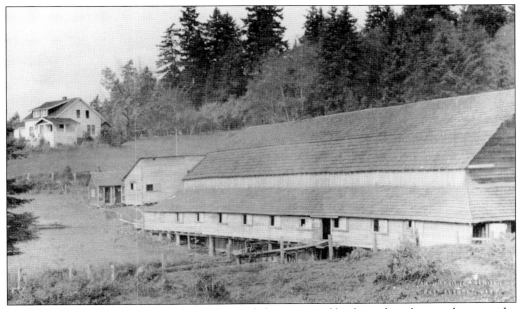

The Peterson residence is pictured in the upper left corner, and his large dairy barn is shown in the front. The Navy bought his farm, which was next to Fort Ward, early in 1941 and converted it to its uses. The Petersons were allowed 30 days to sell their cattle and remove their personal effects. William, his wife, Edith, and two daughters moved to West Seattle, and he found employment in the shipyard at Harbor Island.

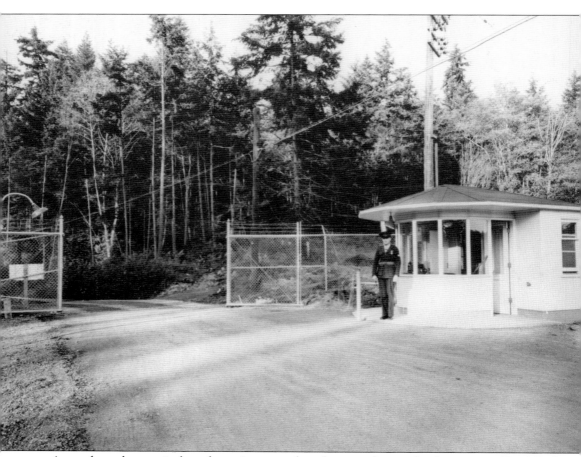

A guard stands attentively at the main gate and gatehouse at the naval radio station at Fort Ward. This image was taken on November 1, 1941, shortly before World War II began. This facility eavesdropped on the Tokyo–to–San Francisco radio net, recording Japanese diplomatic messages sent in Japanese Morse code.

# *Three*

# THE WAR YEARS

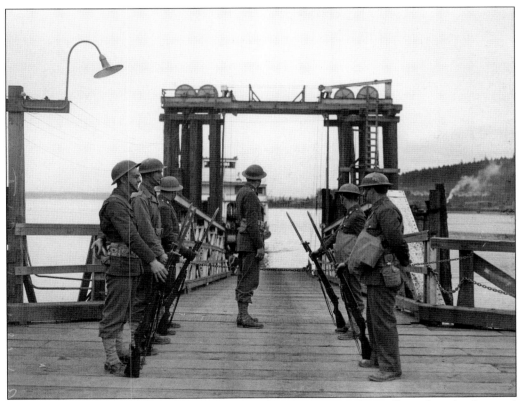

On December 7, 1941, little did anyone realize the almost immediate effects that the Imperial Japanese Navy's attack on Pearl Harbor would have to the Japanese American residents of Bainbridge Island. On the morning of March 30, 1942, after Pres. Franklin D. Roosevelt signed Executive Order 9066, Japanese Americans were removed from Bainbridge Island and taken to Eagledale Dock to be removed from the island, with only six days' notice to prepare.

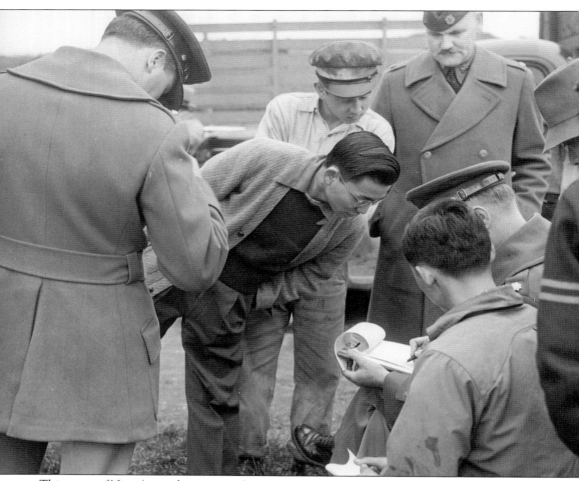

This group of Nisei (second-generation Japanese Americans) was very cooperative with the military officials and helped them as they determined where the exclusion orders should be posted. There were no incidents or violence during the evacuation of the Japanese from Bainbridge Island.

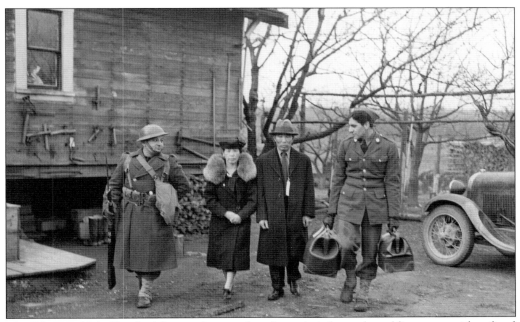

Mrs. Ume and Mr. Yosuke Moji are being taken from their home by soldiers, one with a fixed bayonet on his rifle, to Eagledale Dock to be taken away on the ferry. There was no established date, if ever, that they would be able to return. All belongings they were able to take with them were either worn or being carried by the soldier on the right.

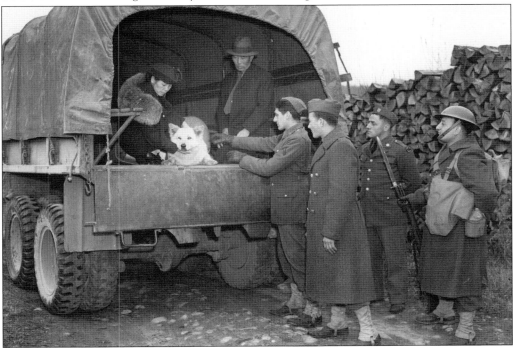

Pets were not allowed to be evacuated, and so Ume and Yosuke Moji had to leave their dog King behind.

His son (left) and neighbor children assisted Henry Takayoshi of Pleasant Beach when it came time to evacuate. Earlier, Takayoshi destroyed albums of his award-winning photography work plus many valuable glass plate negatives. They were burned in the firebox of the family's outdoor furnace.

Seijiro Nakamura, a single parent, looks on with others in his family as two soldiers help his daughter Kiyoko (Ruth) into a truck for transportation to Eagle Harbor during the exclusion evacuation. Seijiro Nakamura was born in Japan on July 1, 1881, and came to the United States in 1900. He registered for the draft during World War I in 1918 and again for World War II after arriving at Manzanar.

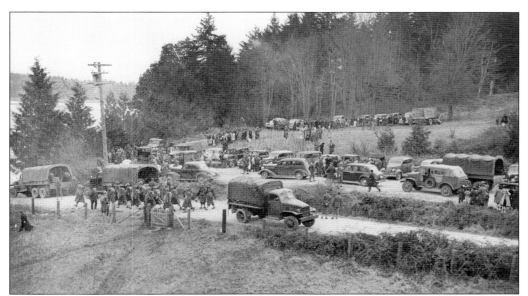

Soldiers are shown marching toward Eagle Harbor in formation with fixed bayonets, getting ready to load Japanese Americans aboard the ferry *Kehloken*. Island residents are there to say goodbye to their friends and neighbors, and the Army transport vehicles used to deliver Japanese Americans to the dock from their homes on the island are visible.

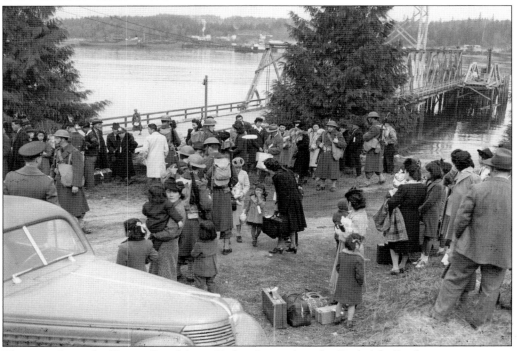

This was the end of Lower Road (now Taylor Avenue) at the Eagledale Dock as everyone was waiting for the ferry to arrive to deliver Japanese Americans to Seattle for their train ride to Manzanar. On the way to Seattle, crewmembers of the ferry went below to say goodbye to their friends that were departing.

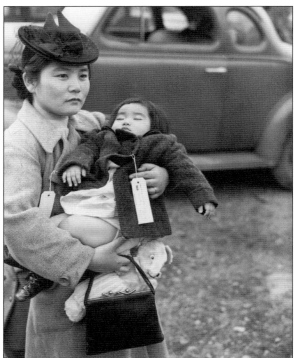

Fumiko Hayashida and her daughter Kayo are waiting at Eagledale Dock for the ferry ride on the *Kehloken* to Seattle with fellow Japanese Americans. The tags that are affixed to each of them are for identification and were to be "retained by the person to whom issued" for the duration of the trip to Manzanar.

Ritsuko (left) and Yoshie Terayama are saying goodbye to their Bainbridge Island friend, as the Japanese American islanders are getting ready to leave on the ferry. This was a very difficult time for all concerned, as they did not know if they would ever see each other again.

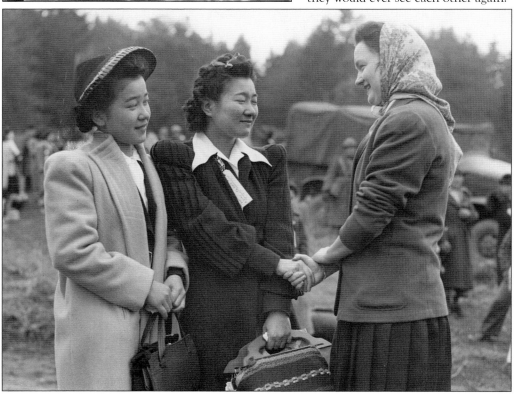

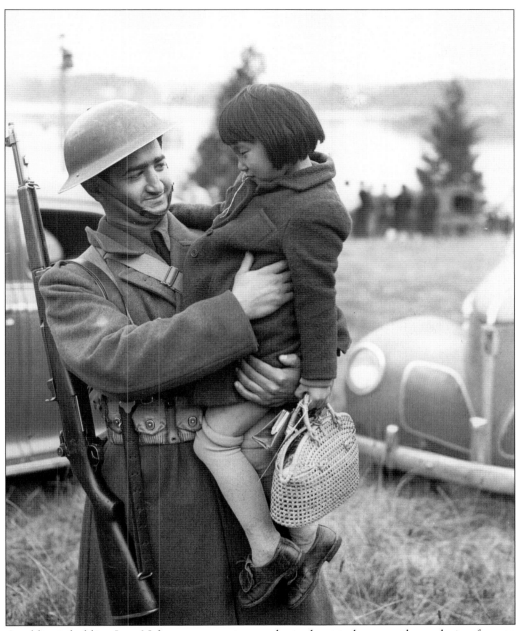

A soldier is holding Jane Nakamura, age nine, as she is about to leave on the exclusion ferry to Seattle. Many of these soldiers had a hard time carrying out their orders.

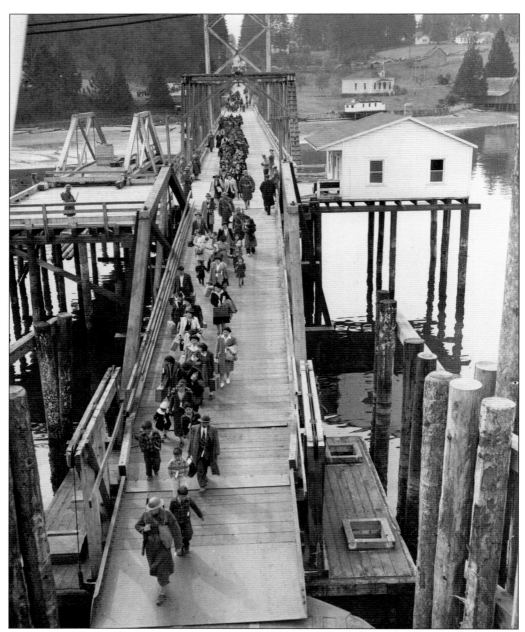

During World War II, 227 islanders walked down what is now Taylor Avenue to board the ferry *Kehloken* to be taken to Seattle and on to Manzanar. The new Bainbridge Island Japanese American Exclusion Memorial now occupies the historic Eagledale Ferry Dock landing site, where this scene took place on March 30, 1942. This site is administered by the National Park Service and the Department of Interior and managed locally by the Bainbridge Island Japanese American Exclusion Memorial Association (BIJAEMA) and the Bainbridge Island Historical Museum.

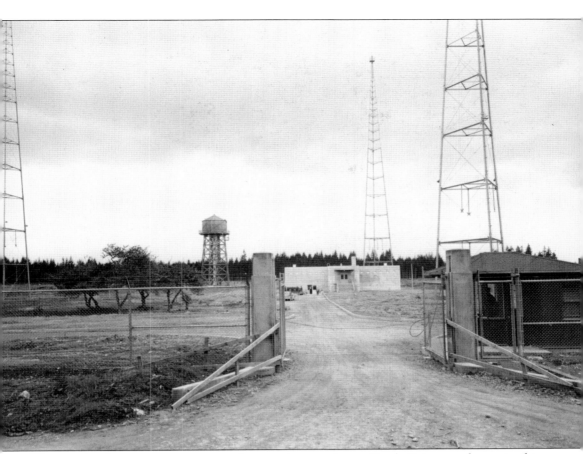

The naval radio station antennas and transmitter station at Battle Point are shown in this photograph taken May 2, 1942. This Bainbridge listening post had radio direction finding (RDF) for locating and tracking enemy ships as well as listening to diplomatic messages from abroad. Using radio signals from several listening stations, RDF could identify a ship's location. This data was then sent to West Coast naval commands and the chief of naval operations in Washington, DC.

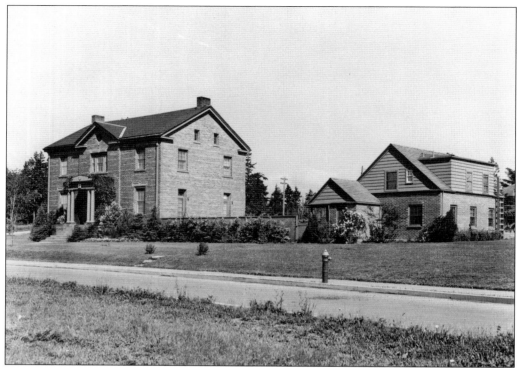

The Fort Ward commander's house is shown here in 1941 with the detached maid's quarters on the right. These facilities are still standing in Bainbridge Island Metropolitan Park and Recreation District in 2013.

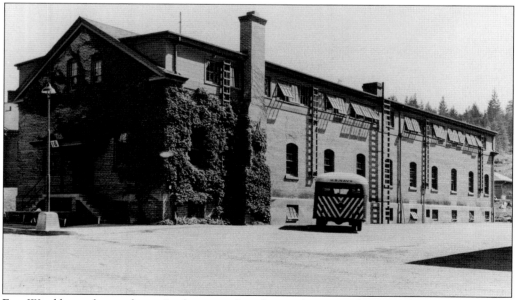

Fort Ward barracks are shown in the active days during the war with a Navy bus parked in front. At the time of this writing, these barracks are still standing, and developers have promoted them for use as office spaces or living quarters.

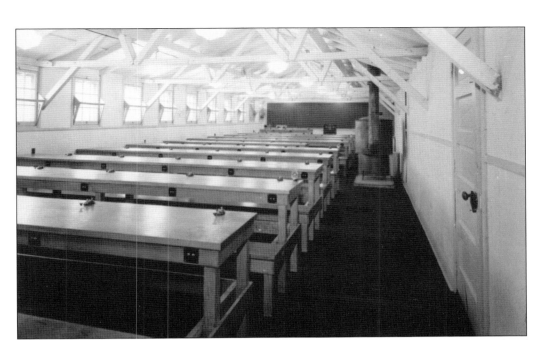

On October 28, 1940, a naval reserve radio school was started that would include four months of training for up to 40 students in each class. These students would learn Morse code, typewriting, naval communications operations, and elementary seamanship. Note the telegraph keys and the headphone jacks on the tables.

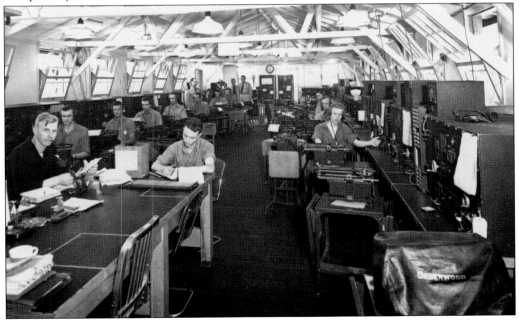

This is an inside look of the top-secret listening post called Station S, Naval Security Group Activities (NSGA) at Fort Ward. Any significant messages heard here were transmitted from antennas at Battle Point, where the transmitting towers were located to avoid interference with the receiving antennas.

Union brevet brigadier general George H. Ward of the 15th Massachusetts Volunteers was wounded at Gettysburg in 1863; Bainbridge Island's military installation was named for him. The fort was designed to protect the Navy yard at Bremerton in the event of enemy attack. In 1938, the Navy acquired the property, controlling it until it was returned to the Army after World War II.

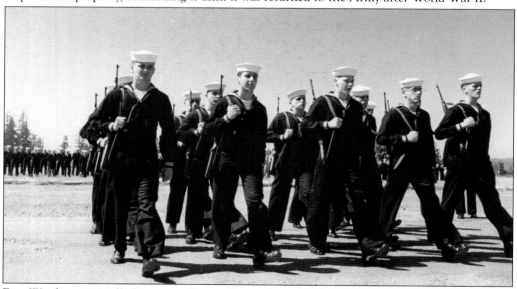

Fort Ward was initially known as Beans Point when the Army established it in 1890 but was renamed in 1903 and remained an Army base until it was put on inactive status in the 1920s. The Navy acquired the property in 1938 and transferred it back to the Army in 1956. The Army abandoned all operation in 1958, and the fort became Fort Ward State Park in 1960 and later, in 2011, Fort Ward Park under the ownership of the Bainbridge Island Metropolitan Park and Recreation District.

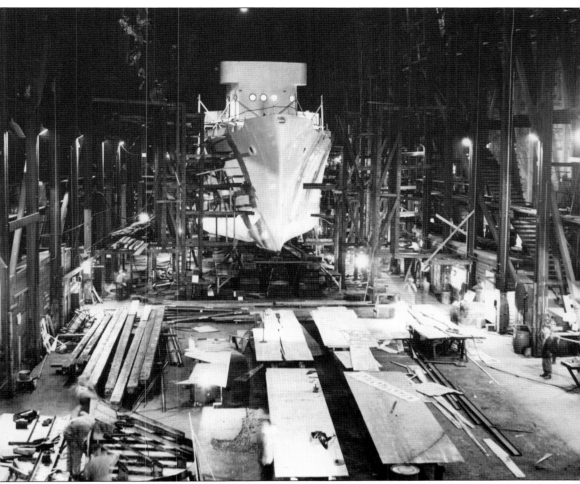

The Winslow Marine Railway and Shipbuilding Company built 17 minesweepers during World War II. Its shipyard was in Winslow and was originally an expansion of Hall Brothers Shipyard. This photograph shows a minesweeper under construction. During the war, as many as 2,300 workers were employed building minesweepers in Winslow.

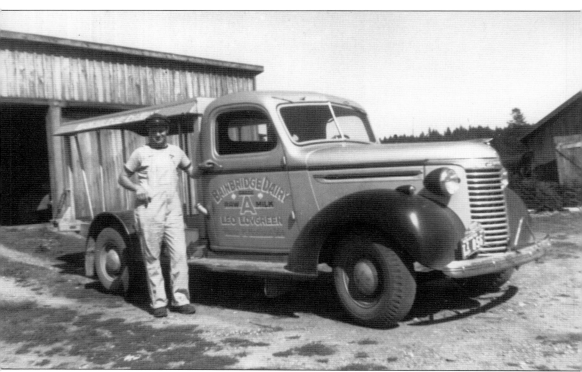

John Lovgreen is standing by a Bainbridge Dairy delivery truck used on the 96-acre farm that the Lovgreen family worked for two generations. His father, Leo, who established the farm, had emigrated from Denmark, and his mother, Minnie, had come from Germany. After graduating from Bainbridge High School in 1937, he married his high school sweetheart, Claire Kane, on July 19, 1941. This photograph was taken in 1943.

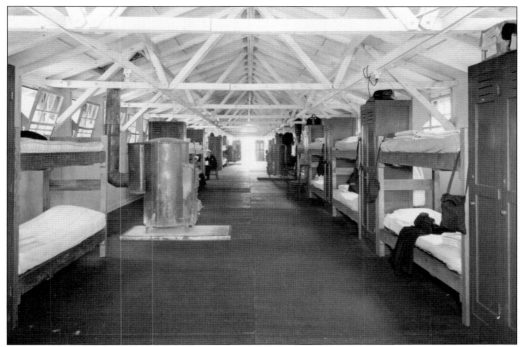

This is a typical barracks scene at Fort Ward during the war years. Most of the military staying at Ford Ward were involved with listening to communications coming in from war activities in the Pacific.

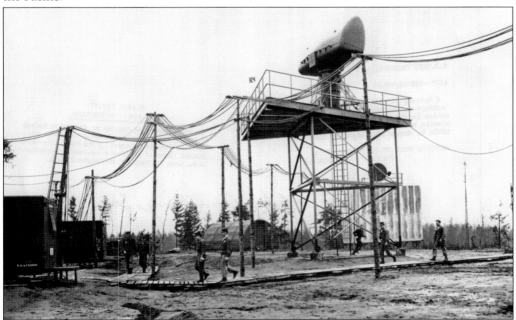

Within Fort Ward, these giant rhombic antennas were built to listen to radio traffic coming in either from Japan or on the war front. Diplomatic as well as ship-to-ship conversations were monitored.

This photograph, which was taken on November 1, 1941, shows four remodeled single enlisted men's quarters. Many military people with communication expertise were being brought to Fort Ward at this time.

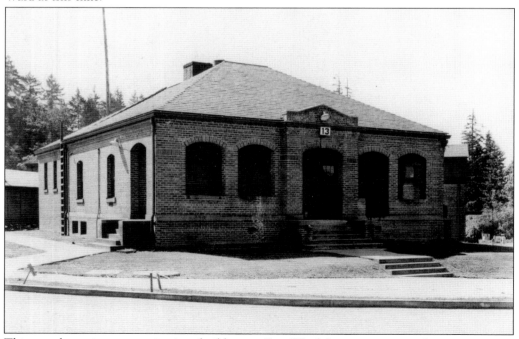

This was the main communications building on Fort Ward. It is now a private home.

*Four*

# AFTER THE BRIDGE

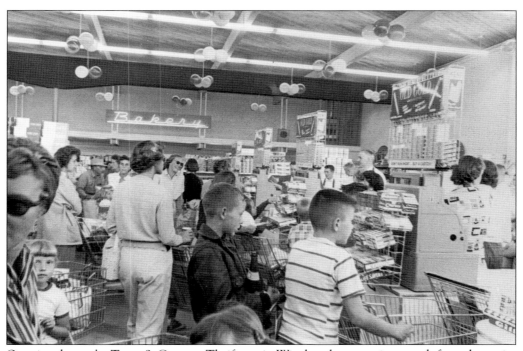

Opening day at the Town & Country Thriftway in Winslow drew massive crowds from the entire island. On August 29, 1957, John Nakata, Mo Nakata, and Edward Loverich opened this store after each had their own respective stores on Bainbridge Island. This grand opening was a large-scale community event including helicopters, heavyweight boxing champions, and personalities from children's television shows. This was the island's first supermarket.

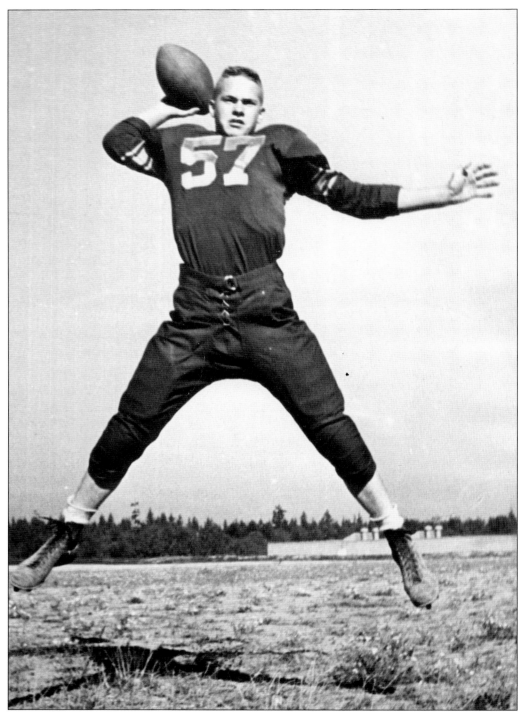

Quarterback William Piggot is showing his form on the 1949 Bainbridge High School football team. Bainbridge High School was built in 1927 but had to be rebuilt after a fire in 1976. At the present time, there are 1,350 student enrolled in the school.

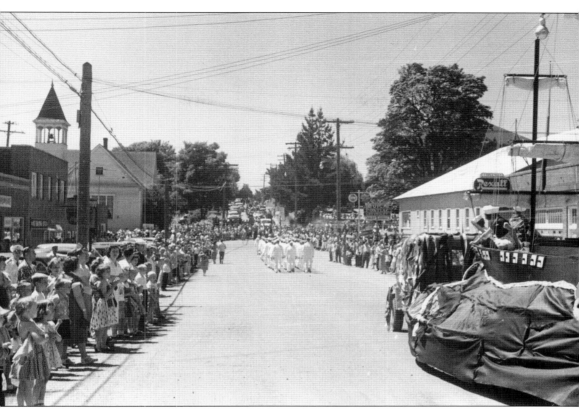

Looking west, this photograph shows Winslow Way during a Strawberry Festival parade. This parade took place around 1955.

Ernie Olsen is shown with the Chevron sign in the background. He is co-owner of Hockett & Olsen in Winslow. This photograph was taken in 1947.

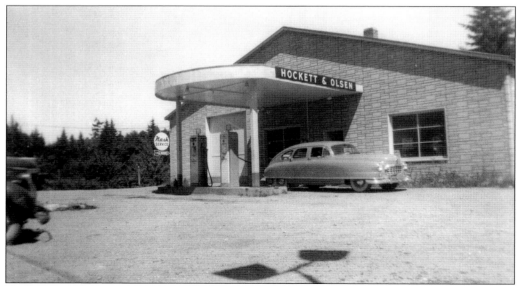

Hockett & Olson service station is located on the southeast corner of Ferncliff Avenue and High School Road. This photograph was taken in 1949.

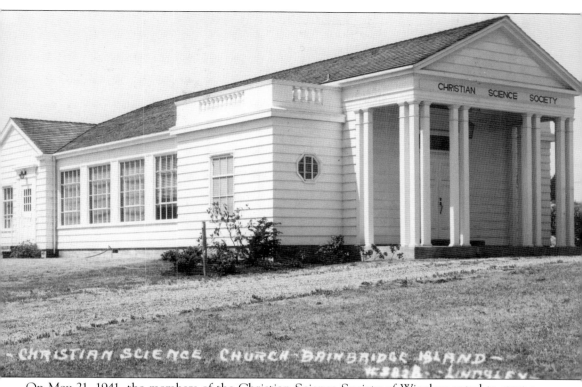

On May 21, 1941, the members of the Christian Science Society of Winslow voted to start a building project. The church was completed on December 28, 1941. On December 8, 1953, the church became known as First Church of Christ, Scientist, Bainbridge Island.

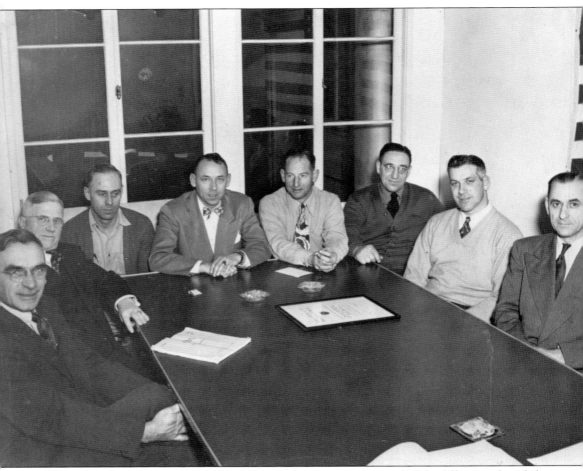

When Winslow was incorporated in 1947, the city council consisted of the following, from left to right: Harold Woodman, Dr. Frank Sheppard, William Roberts (treasurer), Herbert Allen (mayor), Ray Williamson, George Townsend, Edward Loverich, and David Myers (clerk).

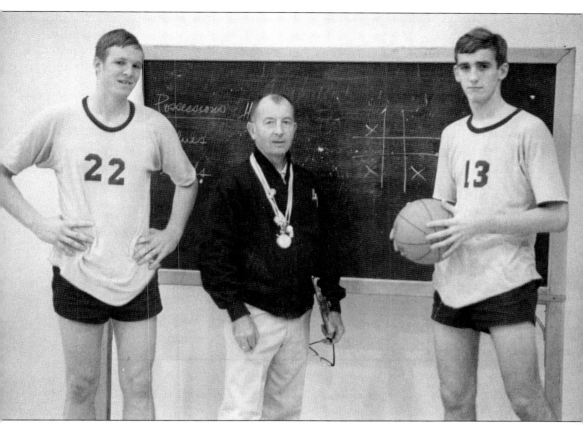

James Blair (No. 22) and Scott Enderson (No. 13) pose with coach Thomas Paski. Coach Paski and these players were part of the 1969 Bainbridge High School basketball team.

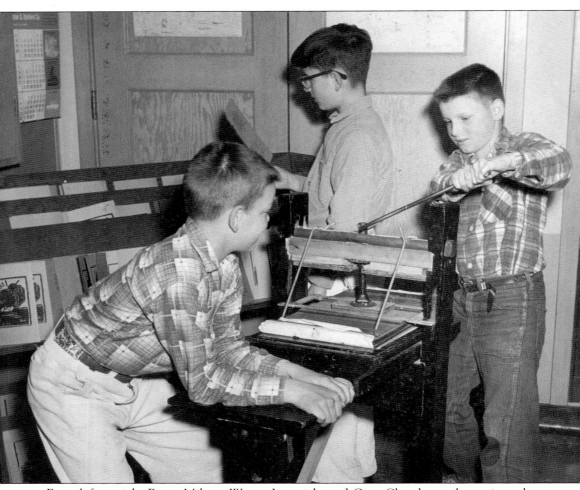

From left to right Rusty Milton, Wayne Loverich, and Gary Clough are shown in a class at Commodore School. This c. 1950 photograph shows them learning early printing skills.

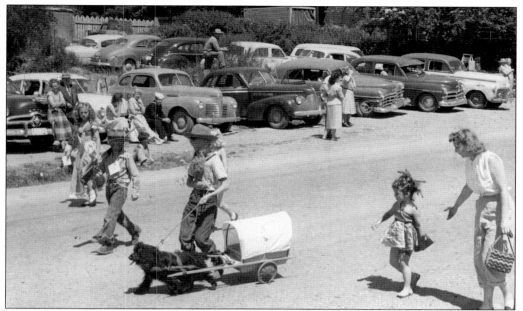

Ralph Munro, at age 10, is shown with his dog Jip, towing a miniature covered wagon, in the 1953 Strawberry Festival Parade. This particular parade down Winslow Way marked Washington Territory's 100th anniversary. Munro would still participate in the annual parade in Winslow, at times, nearly 60 years later.

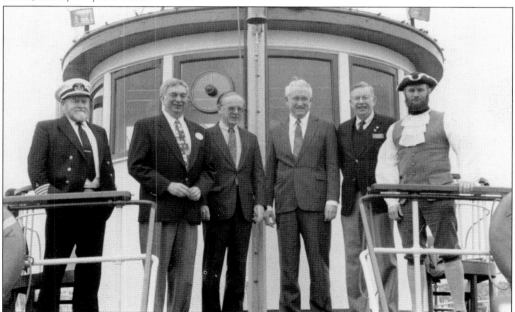

This picture was taken aboard the *Virginia V*, the last of the Mosquito Fleet steamers, in Lake Union on March 4, 1996. Shown from left to right are Capt. Donald Moss, Gov. Mike Lowry, Malcom Munsey of the *Virginia V* Foundation, Secretary of State Ralph Munro, David Williams of the Recreational Boating Association of Washington, and Capt. Lee Bolton of Washington's State Ship, *Lady Washington*.

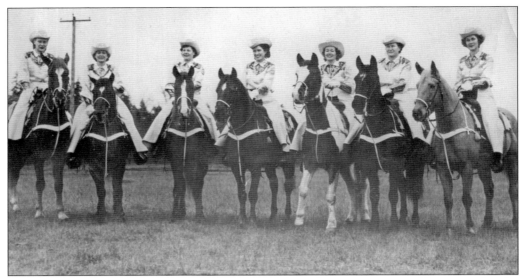

These members of the Bainbridge Island Saddle Club are demonstrating good horsemanship for the photographer. Bainbridge Island Saddle Club, located in Manzanita, includes a large arena with a covered viewing stand, office, judges' tower, cook shack, restrooms, covered picnic area, a smaller warm-up arena, stalls for day use, and water.

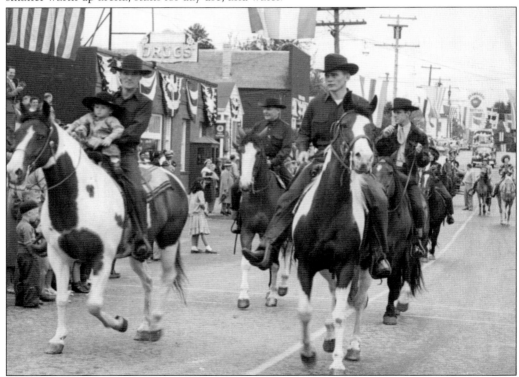

Horace Winney is shown holding his son, Joseph, in front of him while riding in the 1948 Strawberry Festival Parade. Joseph Osier is identified on the horse behind Winney, and the rest of the riders are unidentified.

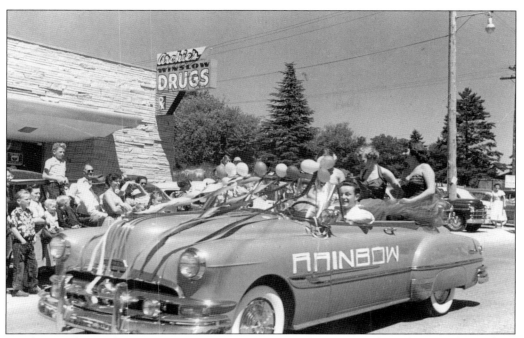

Rainbow Girls are riding in a new Pontiac in a 1950s Strawberry Festival parade. Note the Archie's Winslow Drugs sign in the background above.

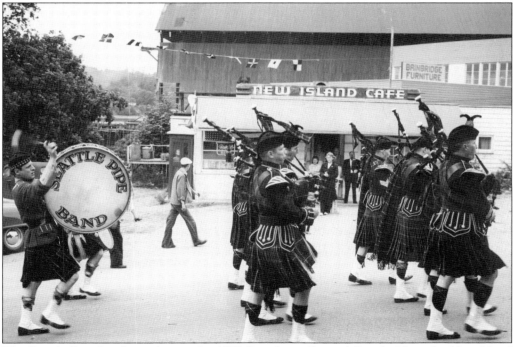

The Seattle Pipe Band marches in the 1950 Strawberry Festival Parade. Note the New Island Café and Bainbridge Furniture signs in the background. William Delany is identified as playing the bass drum.

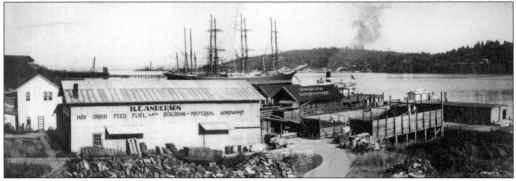

Taken in 1933, this image shows masted ships at dock in Eagle Harbor and the H.E. Anderson Hardware building on Parfitt Street. The Winslow warehouse is shown to the right of the H.E. Anderson building.

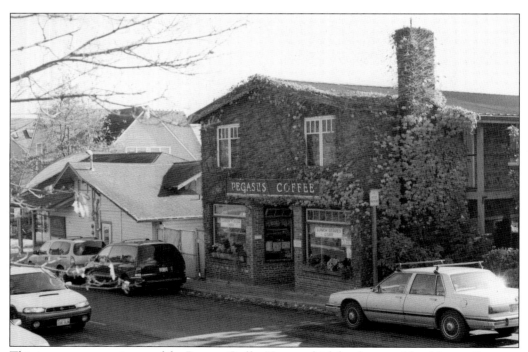

This is a more recent image of the Pegasus Coffee House, which has been an island fixture for many years; the building was formerly home to the H.E. Anderson Hardware store. The bricks that have been used for the exterior of this building were salvaged from the Port Blakely Mill incinerator.

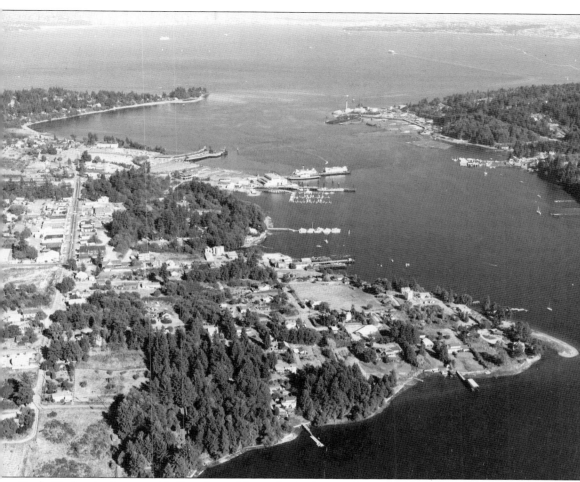

Eagle Harbor is shown, with Seattle visible in the background, much as it appears today. The creosote plant is still visible in this photograph. It has since been dismantled and is being replaced by a park, although the environmental cleanup of the site will go on for many years.

# BIBLIOGRAPHY

Beal, Zoe M. *Bainbridge Island in Battened Buildings and Dipper Days.* Seattle: Dickson–Fletcher Printing Company, 1960.

Kitsap County Historical Society Book Committee. *Kitsap County History: A Story of Kitsap County and Its Pioneers.* Seattle: Dinner & Klein, 1981.

Marriott, Elsie F. *Bainbridge through Bifocals.* Seattle: Gateway Printing Company, 1941.

Neiwert, David A. *Strawberry Days.* New York: Palgrave Macmillan, 2005.

Perry, Fredi. *Port Madison Washington Territory 1854–1889.* Bremerton, WA: Perry Publishing, 1989.

Price, Andrew. *Port Blakely: The Community Captain Renton Built.* Seattle: Port Blakely Books, 1990.

Roberts, Brian, ed. *They Cast a Long Shadow.* Bainbridge Island, WA: Minority History Committee of Bainbridge Island School District No. 303, 1975.

Smith, Phoebe. *Glimpses of Bainbridge: A Collection of Life Stories.* Bainbridge Island, WA: Bainbridge Island Senior Community Center, 1992.

Swanson, Jack. *Picture Bainbridge A Pictorial History of Bainbridge Island.* Bainbridge Island, WA: The Bainbridge Historical Society, 2002.

Warner, Kathy. *A History of Bainbridge Island.* Poulsbo, WA: Bainbridge Island Friends of the Library, 1992.

Woodward, Mary. *In Defense of Our Neighbors.* Bainbridge Island, WA: Fenwick Publishing Group, 2008.

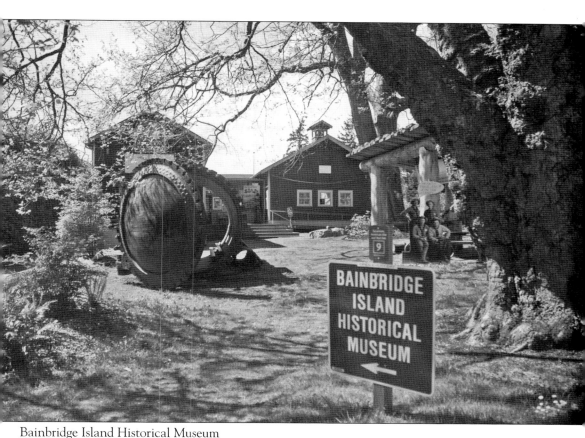

Bainbridge Island Historical Museum
215 Ericksen Avenue NE
Bainbridge Island, WA 98110
(206) 842-2773
A very easy walk from the Seattle–Winslow Ferry terminal
www.bainbridgehistory.org

**MUSEUM HOURS**
Open every day 10:00 a.m. to 4:00 p.m. year-round

**ADMISSION COST**
Adults $4
Students and seniors $3
Family $10
Free admission for Bainbridge Island Historical Museum members and children under five